For
Joe Brown Sr.
and
Eleanor Shropshire

The Art of
NELLIE MAE ROWE

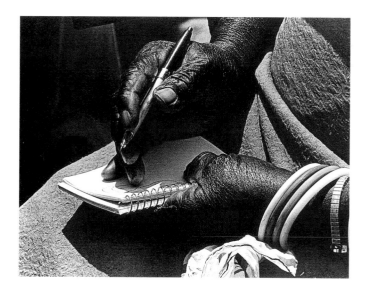

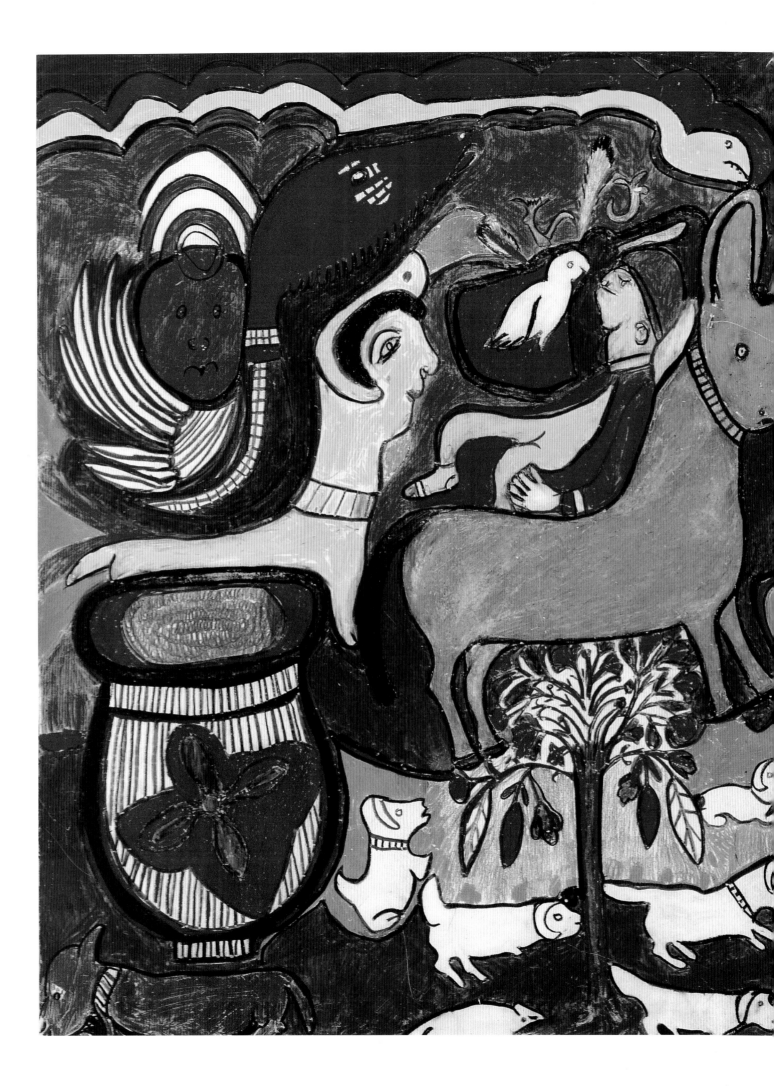

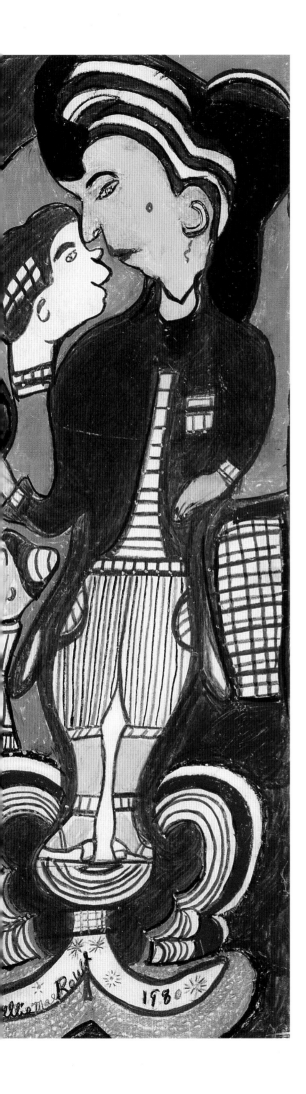

The Art of
NELLIE MAE ROWE
Ninety-Nine
and a Half
Won't Do

Lee Kogan

MUSEUM OF AMERICAN FOLK ART
in association with
UNIVERSITY PRESS OF MISSISSIPPI

Published in conjunction with the exhibition
"The Art of Nellie Mae Rowe: Ninety-Nine and a
Half Won't Do," organized by curator Lee Kogan
for the Museum of American Folk Art.

The Museum of American Folk Art is pleased to
acknowledge The Andy Warhol Foundation for the
Visual Arts and The Judith Rothschild Foundation
for their generous support of the exhibition, the
exhibition catalog, and related programming.

Library of Congress Catalog Card
Number: 98-61473
ISBN: 1-57806-132-6

For the Museum of American Folk Art
Editor: Rosemary Gabriel
Associate Editor: Tanya Heinrich
Copy Editor: Loretta Mowatt

Produced by Marquand Books, Inc., Seattle
Designed by John Hubbard
Typeset by Christina Gimlin
Printed by C & C Offset Printing Co., Ltd.,
Hong Kong

EXHIBITION TOUR

Museum of American Folk Art
New York, New York
January 16 to May 16, 1999

High Museum of Art
Atlanta, Georgia
November 20, 1999, to February 26, 2000

African American Museum
Dallas, Texas
March 18 to May 14, 2000

Distributed by
University Press of Mississippi
3825 Ridgewood Road
Jackson, Mississippi 39211-6492
1-800-737-7788

CONTENTS

ACKNOWLEDGMENTS

Profound gratitude goes to Judith Alexander, Nellie Mae Rowe's friend and art dealer from 1978 to 1982, who recognized the importance of the artist when she first saw her work and who, over the years, has been largely responsible for bringing her art to the attention of a wider audience. Thank you for your full support and involvement in this project and for staying in Atlanta for more than a year to facilitate my many visits.

I offer my deepest appreciation to Judith Alexander, Xenia Zed, and Ben Apfelbaum, who generously shared their research with me, and to Judith M. Anderson, Barbara Archer, Benjamin Jones, and Marianne Lambert—all part of the Atlanta team—who helped to crystallize the curatorial vision in countless ways.

Interviews with Nellie Mae Rowe and her family fortunately were captured on tape and film and add an invaluable dimension to the history of this artist. I wish to thank Judith Alexander, Barbara Archer, Judith A. Augustine, Charles Brown, Linda Connelly, Tom Ellis, Alex Harris, Harriet Miller, Ella King Torrey, and Dr. Maude Southwell Wahlman, as well as family members and friends who participated in the conversations: Roberta Bates, Joe Brown Sr., Barbara Mitchell, L.C. Mitchum, Cathy Perry, and Eleanor Shropshire.

Many thanks to Kinshasha Holman Conwill, director, The Studio Museum in Harlem, New York, and to Gerard C. Wertkin, director, Museum of American Folk Art, whose contributions to the catalog were indispensable.

Enduring thanks to Ginger Michel for outstanding assistance with research, organization, and administrative detail at every stage of the exhibition and book preparation; to Dr. Cheryl Rivers for undertaking important editorial tasks with care and enthusiasm; and to Russell Scholl for energetic research in gospel music.

A thank-you to the Museum of American Folk Art staff: Gerard C. Wertkin, director, for initiating the project and for his unwavering encouragement throughout; Rosemary Gabriel, director of publications, for her patience and attention to detail and the production schedule; Cheryl Aldridge, director of development, for her unfailing interest in the project; Ann-Marie Reilly, registrar, for her meticulous care of the objects; Judith Gluck Steinberg, assistant registrar, for her diligent efforts on behalf of the traveling exhibition; Stacy C. Hollander, curator, for her enthusiastic support as a colleague and friend; Joan Sandler, director of education, for her sensitive and wise counsel; Tanya Heinrich, associate editor, for proofreading the manuscript; Janey Fire, photo services manager, for assistance with photography; Katya Ullmann, library assistant, for library research; and Susan Flamm, director of public relations; Riccardo Salmona, deputy director; Beth Bergin and Chris Cappiello of the membership department; Marie S. DiManno, museum shop manager; and Madelaine Gill, education administrative assistant, for their unstinting cooperation.

Thanks also go to the following colleagues: Pat Cruz, assistant to the director, and Valerie Mercer, curator of the collection, The Studio Museum in Harlem; Richard Gruber, deputy director, and Catherine Wade Wahl, registrar, Morris Museum of Art, Augusta, Georgia; Jack Lindsey, curator of decorative arts, Philadelphia Museum of Art, Philadelphia; Peter Morrin, director, J.B. Speed Art Museum, Louisville, Kentucky; and Lynne Spriggs, curator of folk art, and Marcy Greven, curatorial assistant, High Museum of Art, Atlanta.

Special thanks go to the following individuals: Helen Alexander, Jimmy Allen, Lewis Allen and Stewart Thompson Productions, Emma Amos, Judith M. Anderson, Ben Apfelbaum, Barbara Archer, Mariann Benson, Vincencia Blount, Lynne Brown, Shari Cavin, Annette Cone-Shelton, Greg Day, John Denton, Ann DiSimone, Dorothy Dohoney, Fred DuBose, Franklin Garrett,

Martha Gerschiefski, Kurt Gitter and Alice Yelen, Dr. Grey Gundaker, Rhetta Kilpatrick Horton, Benjamin Jones, Jean Ellen Jones, Marianne Lambert, Deanne Levison, Susan Loftin, Dr. Richard Long, William Louis-Dreyfus, Carol Martine, Jim McLean, Mark Methe, Henrietta Mindlin, John Moore, Randall Morris, Andy Nassise, Michael Norkiss, Claud "Thunderbolt" Patterson, Tom Patterson, Robert Peacock, Mario and Susan Petrirena, Isaac Pollak, Dr. Dan Rose, Chuck and Jan Rosenak, Susan Schlaer, Robert Seng, Anees H. Shahid, Randy Siegel, John Spiegel, Martha and Jim Sweeney, Stewart Thompson, Dr. Rayael and Sylvia Urrutia, Wayne Vason, Gerald J. Wiseman, Xenia Zed, and Suzanne Zelinka.

Thanks also to those who shared their photographs of Rowe and her environment: Ben Apfelbaum, Judith A. Augustine, Lucinda Bunnen, Richard S. Lambert, Sarah Landsdale, Andy Nassise, Dr. Ethan Staats, and Donna Stinger.

—L.K.

FOREWORD

Nellie Mae Rowe had the rare capacity to draw others into a special world of her own creation. This is not to imply that she turned her back on the real world, or that the environment in which she lived and worked was imaginary or illusory. The home that she inhabited was real, after all, and her work was grounded in the here and now, but she brought a magical quality to everything that she did. Those who were lucky enough to call upon her during her lifetime received a warm welcome to a place that was full of surprise and wonder. But to confront her drawings, sculptures, and assemblages today, when she no longer is there to open the door, is no less an invitation to Nellie's playhouse.

A born storyteller, Nellie Mae Rowe wove intriguing tales from the stuff of everyday life. If her narrative is replete with references that have at least a vague familiarity (a stylized row of shotgun houses, for example), there are also hints of deeper—and occasionally darker—insights. It was therefore with growing anticipation that I followed the journey of discovery that Lee Kogan undertook into Rowe's life and art—a journey that led to this comprehensive consideration of the gifted artist's work. Along the way, Judith Alexander, an Atlanta-based collector and dealer, invited Kogan and me to her homes, where I saw the full range of Rowe's drawings, from her early, somewhat tentative strivings to the power-laden, full-blown works that are presented in this book for the first time.

My introduction to Nellie Mae Rowe's drawings occurred earlier, at the home of my predecessor as director of the Museum of American Folk Art, Robert Bishop. On a large brick wall adjoining the staircase in his townhouse in Manhattan's Chelsea neighborhood, Bishop had arranged an enormous selection of artworks. For me, one stood out from all the rest: a painting of a black fish by Nellie Mae Rowe (see no. 65). Almost iconic in presence and perhaps suggestive of a multiplicity of meanings and references, the black fish had such a gutsy authenticity about it that it held its own against the much larger and more complex works of art on display in Bishop's home. Included in the Corcoran Gallery of Art's exhibition "Black Folk Art in America, 1930–1980," the composition typified Rowe's sense of rhythm and patterning, with a use of negative space that introduced an edgy, almost surreal quality—all the more so because of the brooding presence of a group of birds. I often think of that painting, and am delighted that Lee Kogan has included it in the exhibition accompanied by this book.

Almost since its founding in 1961, the Museum of American Folk Art has been receptive to the work of twentieth-century self-taught artists like Nellie Mae Rowe. Creating outside the formal structures of the artworld—the "system" of schools, studios, galleries, and museums—these artists are unaffected by artworld trends, whether established or emerging. To call them "self-taught," however, would seem to suggest creativity uninfluenced by context or tradition. On the contrary, without detracting from the highly individualistic expressive voices with which the most accomplished of such artists speak, their work is often deeply rooted in folk culture, even if it is not dependent upon received forms and conventions. As Kogan suggests, African retentions and African American ideas may be present in abundance in Rowe's work, as may an acute awareness of popular culture and the events of the day, great and small. Indeed, why should we expect otherwise? It is clear, however, that Rowe is also an autonomous, even idiosyncratic creator who brings her own lexicon of form and technique to the artistic endeavor.

By its very mission, the Museum of American Folk Art is devoted to the diverse experiences and cultural expressions of all segments of American body politic; the Museum celebrates diversity. Among the richest and most rewarding of the many folk traditions comprising the fabric of American

8

life is the African American and, more especially, the African American vernacular culture that continues to flourish in the rural South today. This has been a continuing thread in the history of the Museum. In addition to several striking presentations of African American quilts, the Museum has organized or hosted exhibitions devoted to the artwork of Thornton Dial Sr., William Edmondson, Minnie Evans, William Hawkins, Clementine Hunter, and Sister Gertrude Morgan, among others. To be sure, these artists share a common history—one marked not only by the marginalization of their heritage by American society but by transcendence in the face of depredation. While they draw from the same deep wellsprings of culture, they are distinctly themselves, each different from the others. Through this volume and the exhibition that it documents, the work of Nellie Mae Rowe is presented as another chapter in a story of great significance to American life.

For undertaking this fascinating journey, I am grateful to Lee Kogan, who has served for many years as director of the Folk Art Institute, an educational arm of the Museum of American Folk Art. Long a champion of the artworks of contemporary folk artists, she has established an international reputation for her research and writing in the field. As principal author of this book and curator of the exhibition, Lee Kogan has made an invaluable contribution. I am thankful to my colleague Kinshasha Holman Conwill, director of The Studio Museum in Harlem, the nation's premier African American visual arts institution, for the perceptive and eloquent essay that she has written especially for this volume. Judith Alexander, whose devotion to the legacy of Nellie Mae Rowe became a life's work, deserves warm appreciation and abiding thanks for her dedicated commitment to the artist, which I am privileged to acknowledge here. Neither the exhibition nor the book would have been possible without the generous support of the sponsors:

I am deeply indebted to The Andy Warhol Foundation for the Visual Arts and The Judith Rothschild Foundation for their belief in the project and their willingness to underwrite its costs.

To the staff of the Museum of American Folk Art—especially Stacy C. Hollander, curator; Rosemary Gabriel, director of publications; Ann-Marie Reilly, registrar; and Judith Gluck Steinberg, assistant registrar/coordinator of traveling exhibitions—go my warm thanks and appreciation. To them, the lenders, and all those who have participated in the organization of "The Art of Nellie Mae Rowe: Ninety-Nine and a Half Won't Do" goes the well-earned credit for bringing the work of an accomplished American artist to a national audience.

—Gerard C. Wertkin

Director, Museum of American Folk Art

9

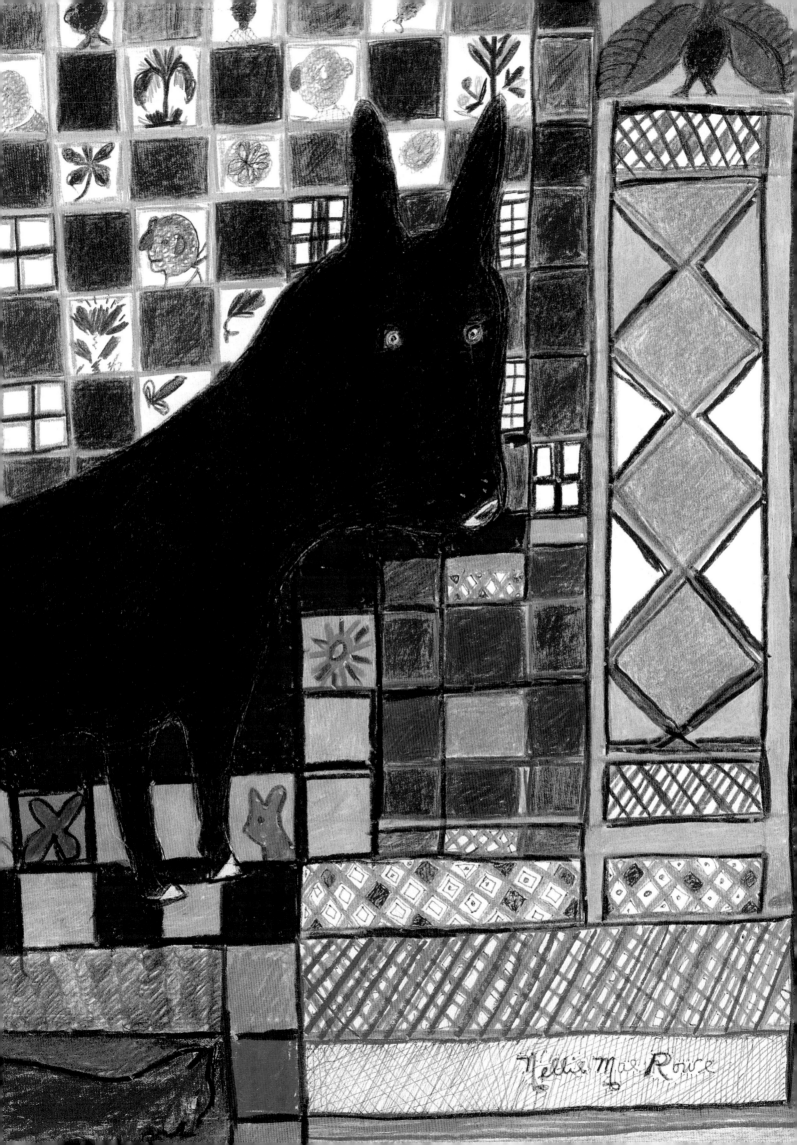

Something that hasn't been born yet:
nellie mae rowe and
the southern imagination

I draw what is in my mind.
I draw things you haven't seen born into this world. *Nellie*
Mae
Rowe

We Southerners are an odd mixture of hope and despair, faith and superstition, charm and subversion. We African American Southerners, particularly those born before the 1960s, often have an ambivalent relationship with our region of the United States. The art of Nellie Mae Rowe and of other self-taught African American artists from the South is defined in no small measure by their genesis in the land that is both the home of the Confederacy and the ancestral home of many African Americans. While some Black Southerners remain at war with their place of birth, Nellie Mae Rowe remained markedly at peace throughout her life and in her prodigious work.

Rowe's birth and life in the South suggest a critical context that places her work within that territory's own fertile heritage, particularly its African American cultural history and artistic practice. Vernacular African American culture, whether in the rich traditions of African American craft and quiltmaking or in the magnificent blues legacy to which American and world music owe such an enormous debt, is a deep well from which many have drawn. The American South, the home of most of the African American self-taught artists who have come to prominence in recent exhibitions and critical attention, is the soil in which much of Black vernacular culture was planted and cultivated. Literary critic Houston Baker speaks of how "the material conditions of slavery in the United States and rhythms of Afro-American blues combined and emerged . . . as an ancestral matrix that has produced a forceful and indigenous American creativity."[1] The history of self-taught Black southern artists has been forged in the crucible of that indigenous culture.

Analysis of the work of self-taught artists by scholars such as Eugene Metcalf, Regenia Perry, and William Ferris approaches this art on its own terms and in the larger context of vernacular culture. Such analysis also differentiates the various self-taught Black artists from one another, rather than generalizing about them. That means separating the inspiration of visionary artists such as painter Sister Gertrude Morgan and woodcarver Elijah Pierce from the works of more secular Black artists such as Rowe, Bill Traylor, and Thornton Dial, whose work is more informed by personal mythologies and vocabularies. (Though Rowe clearly attributed her talent to God, her work is not visionary in the traditional sense.) Such analysis is open-ended as well, acknowledging that meaning is both multivalent and elusive and is not an absolute notion. Finally, the critical role of place in the work of self-taught artists is given its due.

Nellie Mae Rowe's life was marked by her birth in Fayette County, Georgia, in a world that was both modern and steeped in the traditions of the previous century. She lived the last fifty years of her life in Vinings, Georgia, outside Atlanta. Her family's

birth dates resonate with epochal moments in American history. Rowe was born on the Fourth of July in the first year of this century. Her mother was born in 1864, the year after President Abraham Lincoln issued the Emancipation Proclamation, and her father was born into slavery in 1851. Both parents were skilled in handcrafts, an honored southern tradition; her mother made quilts and her father made baskets. Their influence on Rowe and on her decision to make art is evident and profound. The rural life that formed and sustained Rowe held at once memories of self-sufficient farm life, with a large and loving family, and echoes of the post–Civil War era of massive disenfranchisement and unspeakable violence. Rowe was a mature woman before legal segregation was overturned by the Supreme Court in the 1954 *Brown* decision, and she was well into middle age before her home state finally abandoned its strategy of "massive resistance" to civil rights laws. Georgia's, and particularly Atlanta's, response to the civil rights movement was relatively nonviolent, but it was not until Jimmy Carter succeeded Lester Maddox in 1970 that it— Rowe's home state and mine—had its first non-segregationist governor.

Yet Rowe's art does not dwell on either the brutal aspects of southern history or the material deprivations of contemporary rural life. Her work is devoid of rancor and full of wit and infectious joie de vivre. That she was a twice-widowed Black woman of modest means who worked for three decades as a domestic and was seriously ill in her last year of life is not evidenced in her art. Perhaps she continued in adulthood her childhood practice of retreating into her artworld and living more actively there than in the mundane world of laundry, housework, and discrimination. She drew instead, it seems, on the enormous bounty of her rich memories and vivid imagination, creating fantastic (usually friendly) creatures, lush gardens, and brilliantly colored landscapes. As the title of one of her paintings suggests, Rowe was creating "something that hasn't been born yet" or, perhaps, something born of her imagination and made real through her art. In doing so, she joins an impressive group of other self-taught artists, including Sister Gertrude, Pierce, and Traylor, whose alternative visions stand in marked contrast to the work of most of their trained counterparts.

Nevertheless, Rowe's southern roots, her life-long practice of making things by hand, and her imaginative use of found and everyday objects also link her to trained artists such as Faith Ringgold, Betye Saar, Beverly Buchanan, and John Outterbridge. These artists, while of diverse backgrounds and artistic interests, are united in their affinity for the handmade and the ready-made and in an ability to animate the inanimate. Ringgold learned quiltmaking from her mother, Willey Posey, as Rowe did from her mother, Luella Williams. Ringgold's witty narratives make wry social commentary, reference major art historical moments, and move beyond standard quilt traditions. She is also part of a movement of feminist artists who have reclaimed women's work and reignited it with a potent authority. Saar's majestic assemblages and installations are the more learned cousins of the yard decoration that Rowe and her self-taught peers practiced. Buchanan's magnificent monuments to the humble shacks that populated the rural landscape, which both she and Rowe knew well, convey honor and dignity to a people and a lifestyle that were long marginalized. In his decades-long devotion to found objects, Outterbridge, not unlike Rowe, has transformed the detritus of daily life into moving objects that sanctify the quotidian.

Certainly the attraction of the work of self-taught African American artists, with its overtones of romanticism and the lure of "pure" or "primitive" expression, had been used as a wedge against the works of artists like Outterbridge and others. But is Rowe, by being rural and formally untutored, more "authentic" in her expression than her trained counterparts? The more one sees of the work of Nellie Mae Rowe, the more such arguments seem beside the point.

In her willingness to explore the ineffable, the world of dreams, and her own imagination, Rowe creates works that are tremendously engaging. She

makes her vision our vision. The work of self-taught artists can open a pathway to our deepest feelings. Because we often perceive it as more accessible than fine art, it gives us permission for an encounter without the embarrassment evoked by much modern and contemporary art. We are not anxious that we will not understand it. The same viewer confounded by an impenetrable work of conceptual art can look at a Nellie Mae Rowe painting like *Green Parrot* (no. 44) and be delighted by a direct experience of color and composition, unfettered by opaque references to some obscure postmodern intellectual argument. It is pure pleasure—a welcome experience in today's world.

Nellie Mae Rowe "gave birth" to wonderfully complex visions that leapt from her fecund imagination. She evoked her southern heritage in references to the natural wonders of her beloved Georgia. In her hands, parrots dwarf people (and look suspiciously human themselves); the sky is always blue (unless it's green); red fish (and dogs and birds) float freely in gardens that are always in bloom. Rowe's work embraces rather than withholds. She was unlikely to confront or to protest in her art, though given her circumstances, she had every right to. And, in a world of so little generosity and grace, that is a blessing.

At the end of her life, Nellie Mae Rowe said of her own legacy, "If you will remember me I will be glad and happy to know that people have something to remember me by when I've gone to rest."[2] We remember gratefully.

 —Kinshasha Holman Conwill
 Director, The Studio Museum in Harlem

NOTES

1. Houston A. Baker Jr., *Blues, Ideology, and Afro-American Literature: A Vernacular Theory* (Chicago: University of Chicago Press, 1984), p. 2.

2. Judith Alexander, *Nellie Mae Rowe: Visionary Artist, 1900–1982* (Atlanta: Southern Arts Federation, 1983). Excerpts from tapes compiled by Judith Alexander.

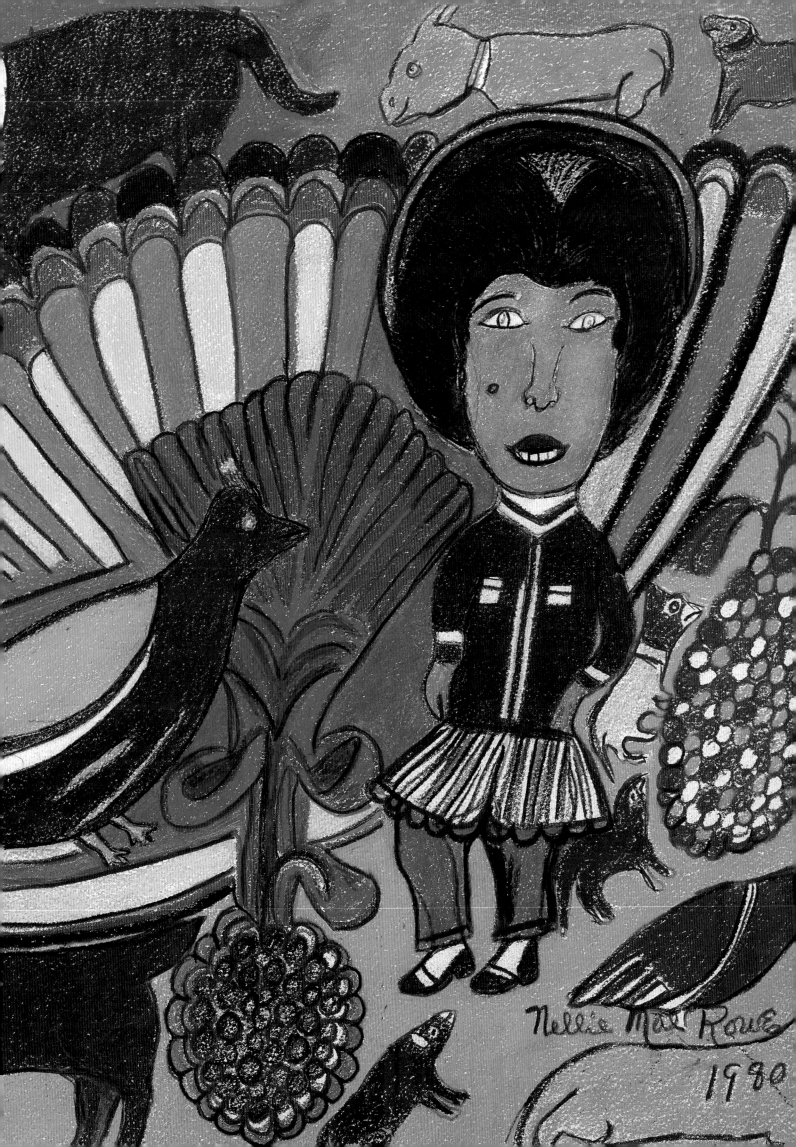

Nellie Mae Rowe

Ninety-nine, ninety-nine, ninety-nine and a half won't do
Ninety-nine, ninety-nine, ninety-nine and a half won't do
You gotta make a hundred, you gotta make a hundred
Ninety-nine and a half won't do

This gospel song, a signature work of Sister Rosetta Tharpe and her mother, Katie Bell Nubin, was not on the funeral service program for Nellie Mae Rowe, but Rowe's friend Barbara Mitchell remembered a promise she had made to the Georgia artist. Following the formal service, Mitchell quietly rose and sang in her full-bodied mezzo. The gospel song, whose terse text and simple melody offered infinite possibilities for improvisation and "bending" of notes or pitches, summed up Rowe's life credo. Rowe was committed to God and absolutely dedicated to living life to the fullest—with energy and without artifice. Uncompromising, she believed that nothing less than one hundred percent would have been sufficient.[1]

Through her drawings, paintings, dolls, chewing-gum figures, and polychromed three-dimensional objects, Rowe created a world and invented a language of symbols that combine with commonplace objects. Her drawings and paintings unite memories and dreams. Her people, birds, animals, houses, trees, and plants defy gravity as they float in space. An occasional body part—a foot or hand—is intermingled with other forms. Rowe's art expresses her inner and outer life. She appears in her pictures as a woman or disguised as a dog, mule, seductress, butterfly, or bird; her shapes reflect her mood and express her feelings about life and death. Thinking about what Rowe has said about her life and art, or considering her symbolic references in the light of Jungian or other psychoanalytic systems, gives rise to intriguing theories about her work. But in the end, the meaning of her art remains elusive.

Without ever reading the writings of James Baldwin, Rowe seemed to follow his advice to "go back to where you started, or as far back as you can, examine all of it, travel your road again and tell the truth about it. Sing or shout or testify or keep it to yourself; but know whence you came."[2] Rowe's art mirrors her journey toward "liberation and self-determination."[3] Her journey takes several forms and her perceptions link seemingly disparate realms into a unity of living forms: earth and heaven, reality and fantasy, spirituality and sensuality, transfiguration, time and space. As art historian/psychoanalyst Gilbert Rose has observed, hers is a primary process perception, a "wide-ranging, fluidly merging, holistic, or imaginative" method in combination with a sharply focused secondary process that delineates clear boundaries. Rowe creates "objects that float, combine, separate, recombine; opposites coexist; structures are unstable and boundaries are fluid."[4]

The artistic talents of her parents fueled Rowe's imagination and creativity. Her father, Sam Williams, was an expert basketmaker, and her mother, Luella, was a quiltmaker and singer of gospel hymns. Early in life, Rowe showed an interest in making dolls by tying socks and other articles

of the family laundry into recognizable shapes. Her parents encouraged her creativity but questioned their daughter's appropriation of the laundry for artmaking. Rowe also loved to draw, preferring art to the unending chores associated with domestic and farm work.

Rowe's niece Eleanor Shropshire recalled that her grandfather, Nellie's father, was a renter, not a "halver" or sharecropper, somewhat unusual for a southern black farmer of that period. With a talent for "figures," Sam Williams, a respected member

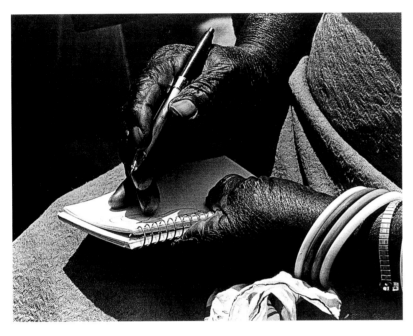

Nellie Mae Rowe's hands, 1979

of his community, managed his farm in a businesslike way with enough money to pay rent. His income from making baskets, shoeing mules, caning furniture, and making syrup supplemented money earned from farm crops.

Nellie Mae Williams was born July 4, 1900, in rural Fayetteville, Georgia, about twenty miles south of Atlanta.[5] The family lived in a large, "old-fashioned," two-story white house with a basement. Her father rented it from Dr. Ellis Loyd after Loyd moved his practice to South Carolina. The property was located near the Sumner Road exit off Highway 54, close to Bennett Lake. The farm and several others, which no longer exist, have been replaced by a new upscale residential community. For Sam Williams, who was born a slave in Mayweather County, the Loyd place was a source of pride. He

often reminded his family of the days of slavery; he remembered that even when there was enough food, he suffered the degradation of receiving it in a hogs' trough.[6] Williams was independent and proud to be able to sustain his family—his wife, Luella Swanson, and ten children: nine daughters, Lila, Tom, Jim, Bob, Eva, Mae, Nellie Mae, Willie, and Sara Ann, and one son, Timothy.[7] The family grew cotton, peas, corn, potatoes, peaches, plums, and muscadine grapes. Two mules, Molly and Mike, and a horse, George, helped with the heavy farm chores. Favorite dogs were Hoop and Holler and Chaw and Swaller. Pigs and poultry supplied eggs and meat for the family. The farm also had a smokehouse, where Williams butchered and preserved meat.

Shropshire and Rowe's nephew Joe Brown Sr. remember holiday visits to the Williamses' and wonderful meals and fun outdoors. Rowe, when young, entertained with "fireballs"—rag balls soaked in kerosene, mounted on a stick, lit, and thrown up in the sky. Sometimes, she would take time after the holiday celebrations to draw or make dolls. The children played mulberry bush and hide-and-seek, shot marbles, and jumped rope. Music was also part of family celebrations. Grandmother played the organ by ear and sang gospel music and hymns accompanied by Rowe on the bass drum. Her siblings blew horns and strummed the guitar. But the main event was dinner, a barbecued feast prepared by the men. The women supplied tea, cakes, and pies. After the meal, the family went to church. At Easter, everyone dressed up, and the children presented recitations. The family regularly attended Flat Rock African Methodist Episcopal Church, about three miles from their home. The church, more than 104 years old, is the oldest active congregation in the area. The schoolhouse that Rowe attended for three or four years was Fellowship Hall, adjacent to the church. Next to the church is the small cemetery where she and her family are buried. Small vases and bouquets of colorful flowers adorn the graves, and cedar, oak, and persimmon trees hover over the stone marker for Nellie Mae Rowe and her family.

Shropshire also remembers other family pastimes such as fishing for perch, eel, and catfish in nearby Bennett Lake. While Rowe claimed not to be especially fond of fishing, fish later became important subjects in her artwork. A short, handwritten, as yet unidentified poem found tucked in a book among her effects clearly points to Rowe's familiarity with fishing and to her sense of humor.

Anglers Prayer
Lod give me Gace
to catch A Fish
So big That even I
When telling of it
it afterward
may never need
to lie[8]

In 1916, Rowe married Ben Wheat. They lived in Fayetteville until 1930, when, seeking better opportunities and following her nephew Joe Brown Sr. and his wife, Gracie Mae, the couple moved to Vinings, a small rural community northwest of Atlanta across the Chattahoochee River. During the Civil War, General Sherman and his Union troops gathered in Vinings, where Vinings Mountain, 1,170 feet above sea level, was a perfect vantage point from which Sherman could observe Atlanta and plan his attack on the capital. The town had a dirt mill and was a transportation center. The small community was more harmoniously integrated than many Southern towns, although social and economic inequality persisted. According to Joe Brown Sr., whites and blacks worked and ate side by side in the fields, especially in the difficult years of the Depression. Sometimes whites prayed in black churches, and because the town was small, members of the two races lived near one another and shopped at the same market.

Nellie and Ben Wheat settled on a farm. Times were difficult, and Nellie found it necessary to supplement the couple's income with domestic work. After Ben Wheat's death in 1936, from cardio-vascular renal disease and from complications following blood poisoning after being kicked by a mule, Nellie Mae Wheat's life became increasingly

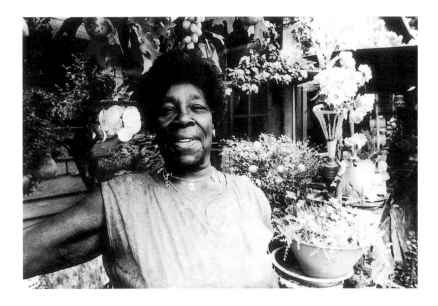

Nellie Mae Rowe in her yard, c. 1980

difficult. She spent almost a year with Joe and Gracie before marrying Vinings resident Henry "Buddy" Rowe, a widower with three children. Much older than his new wife, he was, according to her, a good man and husband. In 1937, they built a house at 2041 Paces Ferry Road, where the couple lived until his death in 1948 and hers in 1982. The house no longer exists, but on the site where the Rowes lived, currently owned by the Windham Gardens Hotel, is a small shaded area and a marker honoring the artist.

For the next thirty years following Henry Rowe's death, Nellie Mae Rowe worked as a domestic for Mamie Lynn, for Ann Jones, and for Vera Smith (Mrs. R.D. Smith), who lived across the way on Boulevard Hill Road.[9] Rowe described her work for Mrs. Smith with affection. She was required to wear a uniform and cap at work, but enjoyed a measure of freedom and was allowed, among other things, to rearrange the furnishings. She also took time to draw and, on occasion, drew portraits of her employers. Mrs. Smith liked Rowe and in the 1970s sold her a green 1956 Chevrolet that allowed the independent Rowe the opportunity to do her own marketing and other chores.

Although Rowe continued to work after Henry Rowe's death, her early interest in art accelerated. She decorated her house and yard with dolls, drawings, and collected objects, calling her environment her "playhouse." "I would take nothin' and make somethin' out of it," she often said about the

objects she collected.[10] The activity filled her time and helped her dispel loneliness after losing her husband. This may have been Rowe's first opportunity as an adult to fully address her creative needs. Rowe decided never to remarry, to concentrate instead on her playhouse and artmaking.

After Rowe began to decorate her house and yard, social visits increased. People were curious about her eye-catching yard decorations. At first, some of the reactions were negative; a few people called her a fortune-teller or "hoodoo" and threw things at her house, broke windows, tore up flower beds, and ripped decorations from the property and spread the contents all over the road. Saddened, she followed Joe Brown's advice and prayed. In time, the assaults stopped, and people's reactions changed. The artist bore no malice to her onetime antagonists. Instead, she was grateful for people's interest. Rowe welcomed visitors, asked them to sign a "guest" book, and escorted them around the property. More than eight hundred people signed Rowe's guest register between May 27, 1973, and March 15, 1975, including folk art curator and collector Herbert Waide Hemphill Jr. On November 9, 1974, he wrote in the guest book, "What a wonderful time!"

Rowe was gregarious and loved popular entertainment. She attended a local dance hall and several clubs in Atlanta with some regularity. She enjoyed movies and stage shows at the Grand near Peter Street and at 81 and the Strand on Decatur Street.[11] African Americans were permitted to attend shows at the Fox and the Grand theaters, but until around 1961 they had to go upstairs to be seated in a segregated area. Another entertainment interested Rowe: wrestling, an immensely popular sport in the 1970s. She attended matches at the Atlanta Lakewood Stadium and the City Auditorium, which had a capacity of six to seven thousand. Rowe also followed matches on local television channel 17, enjoying the National Wrestling Association, and Ann Gunckel's, Eddie Einhorn's, and Gordon Sole's organizations, to name a few.[12]

Though sociable, Rowe hated gossip and kept her troubles private. For years, she suffered with cancer but confided only in her nephew. She carried on in spite of pain and discomfort. "God gave me a special talent," she would frequently remark, and she did not waste it.[13] She traveled to New York in 1979 with her friend and dealer Judith Alexander and the photographer Lucinda Bunnen for the opening of her exhibition at Parsons/Dreyfus Gallery. Though recovering from injuries received when she was knocked over by a car back home, she enjoyed New York. And although too weakened from cancer to attend the exhibition "Black Folk Art in America, 1930–1980," at the Corcoran Gallery of Art, Washington, D.C., in 1982, Rowe was pleased to see her work in the catalog. Rowe was hospitalized several times in 1981 and 1982 and spent her final weeks in the hospital, where on October 18, 1982, she died of multiple myeloma. Many of her late artworks hint at death. For example, a rooster, depicted in 1972 in bright green—*Green Rooster* (no. 1)—was drawn again in 1982 in somber black with a touch of dark blue—*Black Rooster* (no. 84).

Paces Ferry Road, where Rowe's single-story frame house and yard were situated, was the main Vinings road. The exhibition catalog *Missing Pieces* states, "A short distance from the Governor's mansion lives Nellie Mae Rowe, a black woman who has hung plastic toys and cast-off objects from the limbs of trees in her front yard." Inside her small house she has "covered the walls with photographs, crayon drawings which she has made, plastic flowers, and gifts from people who come to see her house and to meet her. She has made a number of stuffed dolls which have hair wigs, marbles inset for eyes, and sometimes children's plastic eyeglasses."[14] The yard was an extension of the exuberant interior of Rowe's house. While unusual in any neighborhood, it was very much in line with environmental arrangement and embellishment by African Americans, especially in the rural South. As noted by anthropologist Grey Gundaker, some African Americans "decorate, dress, or work their yards using a flexible visual vocabulary. The makers of these special yards work to please themselves" and the "work takes personal inventiveness, a cultural

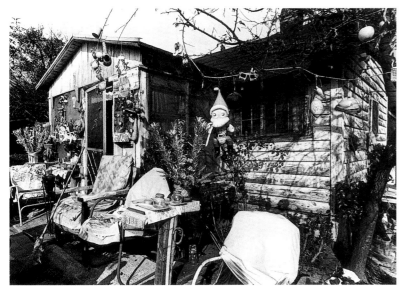

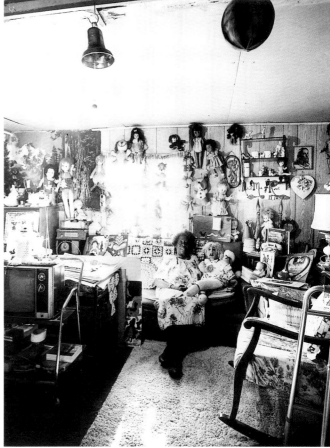

repertoire of signs" that are "elaborations of a code only partly visible."[15] "Far from being either mere enactments of decorative routine or eccentric gestures toward some ever receding horizon outside culture . . . dressed yards contribute to and are shaped by the ongoing cultural processes that make sense of everyday works and lives."[16] Art historian Robert Farris Thompson comments that objects in these yards "of ordinary use and ordinary meaning translate, via spiritual redesignation, into realms of liberation and transcendence." He adds, "One of the traditions characteristic of the greater Afro-Atlantic world is the spiritualization of found and recycled objects placed in yards."[17] Furthermore, Thompson likens recycling of objects in African American yards to the structure of jazz. Each has elements of spontaneity and improvisation.[18] Landscape architect Richard Westmacott has described and interpreted vernacular African American gardens and yards in the rural South as places "expressing values, aesthetic preferences, and spiritual beliefs." Remnants of African traditions, they "are places where independence is asserted with extraordinary vigor and resourcefulness."[19]

Gundaker, in tracing historical patterns that may have originated in Africa, refers to slave culture's strong sense of "personal territory" and "time devoted to gardens, houses and furnishings." Objects with long traditions include topiary, bottle trees, and chairs.[20] Rowe trimmed her bushes in topiary fashion to resemble animals such as sheep,

roadrunners, elephants, and ostriches. Christmas ornaments hung from the plum trees near the front doorway, resembling African and Caribbean bottle trees, and chairs were arranged in ordered ways. A decorated altarlike table further enhanced the effect and importance of the front door as a threshhold. Large guardian dogs and a pirate head were on display; their facial expressions were cool, calm, and composed.[21] Gundaker theorizes that such faces mediate dangerous worldly situations and "stare pointedly" to "remind potential transgressors that they have been seen and are accountable for their actions." The faces and heads "assert that the interior is a 'safety zone' off limits to negativity."[22] Birds, flowers, disks, bottles, fruit, shoes, hats, and other articles of clothing further relate this garden to other rural southern yards.

Rowe's creativity and improvisation in her yard arrangements grew out of family tradition. Her parents' yard, primarily a work space, was swept clean.[23] Sam Williams made baskets under a tree and did blacksmithing, and Luella Williams washed clothes in the yard. Joe Brown suggests that

Nellie Mae Rowe's yard, 1971

Nellie Mae Rowe, April 1982

19

the yard was swept to keep snakes away. Rowe swept her yard with a dogwood broom[24] and covered the path near the house with carpet.[25] African in origin, the swept yard has been a continuing element of transatlantic tradition, providing a space for work and leisure and separating the domestic sphere from the wild.

The interior of Rowe's four-room cottage was also consciously "done." Hospitality was key, with a couch, bed, or chair in every room. On a screened-in porch was a sofa piled high with quilts, floor-to-ceiling drawings in progress, and all sorts of "junk."[26] Grandniece Cathy Perry recalls childhood visits to Aunt Nellie's house, remembering it as a "fascinating place to be filled with lots of surprises."[27] Rowe hung or placed dolls everywhere; she arranged drawings, photographs, plaques, and small objects on tiered shelves and hung them from the ceiling. She draped an afghan, hand-crocheted in the granny square pattern, over the sofa. Knick-knacks, ranging from signs with popular slogans to religious articles, covered every surface. There was a small electric organ, a telephone, and a television set.

Music was integral to the artist's life, and Rowe often played and sang for visitors. Like her mother, Rowe performed only gospel songs, never blues, the "devil's music." Her abiding faith is evident in the video *Nellie's Playhouse*, in which she appears singing the well-known line "Call on God and tell Him what you want"[28] and accompanying herself on her small organ, an instrument she played by ear. She also sings the well-known spiritual "Hush, Somebody's Calling My Name."[29] Rowe attended her local church less and less frequently after the services came to focus more on text than on music.

However, while Rowe preferred music to preaching in church services, she embraced text in her art. Rowe harmoniously combined text and images in her living space and integrated them in her drawings. Her messages range widely. Some drawings were inspired by wall plaques in Eleanor Shropshire's cheerful Fayetteville home,[30] such as "If you want to be seen, stand up/If you want to be heard, speak up/If you want to be appreciated, shut up" and "My house is clean enough to be healthy and dirty enough to be happy." *When the Eagle Flies* (no. 68) is derived from African American slang popular in the North and South in the 1950s and 1960s and refers to Friday as payday, the eagle symbolizing the image on the American one-dollar bill. An earlier source may have been Proverbs 23:5, "Wilt thou set thine eyes upon that which is not? for riches certainly make themselves wings; they fly away as an eagle toward heaven." Popular song lyrics were a stimulus for Rowe's creativity. The line "when the eagle flies" appears in "Stormy Monday," a 1950s blues tune popularized by black singer Lou Rawls and the Allman Brothers Band. Gospel songs inspired the drawings *I Have a Ride at Last* (no. 80), which refers to Rowe's approaching death, and *Look Back in Wonder How I Got Over* (no. 83). Other drawings with text not necessarily related to music include *I Might Not Come Back* (1982), *I Am Worrie* (1982), and *I must keep runing own cant turn around now, I must get own the right road* (1982). The title of *Real Girl* (no. 58), which features a decorated heart surrounding a photograph of Rowe, is a variation of "real woman," African American slang for a heterosexual woman.[31]

More abstract and subtle meanings are evident in *Bad Girl* (no. 62), a drawing dominated by a well-dressed but barefoot young woman. The grinning figure suggests that "bad" means "good";[32] the figure has experienced the sensual aspects of life. After describing herself as a "bad girl," Rowe recounts two childhood dreams in the text of the drawing: "I am a bad girl. Lod God no who I am. This world is not my home," and "When I was a little girl 16 eanche tall I ram my hand down my throat and I pull out forty fishes. I rand and told my mother and she said it was not so. I rand my hand down my throat and pull out forty more." Biblical references to the number forty are many: the flood lasted forty days and forty nights (Genesis 7:4); the Israelites wandered for forty years in the desert (Exodus 16:35). In the New Testament, Jesus is in the wilderness for forty days and forty nights (Matthew 4:2). While Rowe may not have been familiar with all of these references, she certainly knew several of them. The fish in her dream are

clearly a reference to Jesus' miracles in providing sustenance for his followers, but combined with the detached body parts, they have sexual connotations and might account for her words "And the devell I got me. I got to get myself together," as she refers to her need for salvation. On many occasions Rowe described herself as a "bad" and "mean" child. In addition to relating how she defied her mother, Rowe recalled a painful childhood memory of killing rats with a hat pin.

Detached body parts reflect an aesthetic sensibility that anthropologist Dan Rose finds both in Africa and in the Americas.[33] Such body parts occasionally appear in Rowe's drawings, and *Bad Girl* includes a head, a hand, a foot, and breasts. The detached head and bust in the drawing suggest the source of knowledge and power and may be traced to African and Afro-Caribbean cultural traditions. A large pirate head mounted near the entrance to Rowe's house further assumes a protective function. Similarities to other symbols in vodun are provocative. Arms in vodun are symbols of strength,[34] and an occasional detached foot or leg has been thought of as a "concentrated locus of energy" potentially "packed tight and shot out," allowing the "sacred into the profane."[35] While interpretations based on transatlantic symbolism must remain speculative, Rowe's work appears to show cultural continuities that are remarkable.

The use of words intermixed with graphic elements is sometimes descriptive, for example, *Thunder Bolt Pattson [Patterson] Rassler* (no. 6); occasionally narrative, *If You Ar on You Way to the Moon I Will Try the Sun* (no. 77); often spiritual, *Peace Lod, God is Love, Praise God;* or symbolic, *I Will Take You to the Market* (no. 64); and frequently significant as decorative patterning. Rowe used letters and words to identify herself in her pictures. Her florid signatures appear on large compositions and stand alone as elaborate artworks. Rowe's grandniece Cathy Perry remembers that her aunt often passed around paper and crayons to all the children and challenged them with, "I bet you can't write your name as pretty as I can."[36]

Always concerned with the narrative element, Rowe paid equal attention to scenes of everyday life and to fantasy, sometimes drawing naturalistic scenes and sometimes merging the everyday with the fantastic. In *Picking Cotton* (no. 18), a naturalistic drawing, a male figure is bent over with his back to the viewer, a cotton basket nearby. In *Nellie's Teapot* (no. 32), the teapot on a stove seems at first glance to be an indoor domestic scene, but closer examination suggests that the teapot may have fecund power. *Washday* (1981) nostalgically chronicles the routine washday activities prior to the era of washing machines and dryers. Used outside the house, the wash pot, soap powder—in one instance, a box labeled TIDE—and a wash stick are all pictured. *Making Soap* (no. 57), a variation on *Washday,* shows a seated figure, possibly the artist, cooking outdoors. A stirrer is nearby, and a large kettle simmers above an open fire some distance from the house. Rarely content with simple narrative, Rowe includes a whimsical haint (spirit) peeking around the side of the wash pot. Among Rowe's works, from improvisatory sketches to complex paintings, the world of fantasy is a recurrent thread. *Something That Ain't Been Born Yet* (no. 4) humorously combines human and animal shapes. The mass of lines around the head suggests a complex tangle that defies comprehension. While young Rowe believed in the existence of haints, they are typically presented in jest. However the creature in *Blue Striped Devil* (c. 1950) bears a marked resemblance to Bosou, the three-horned bull associated with fertility and protection in Haitian vodun religion.[37]

Rowe merges forms, and her works often contain hybrid figures such as a dog/human, a cow/woman, a dog with wings, and a butterfly/bird/woman. Questioned about some of these creatures, she was evasive, calling them "varmints" or "something that ain't been born yet." *Cow Jump over the Mone* (no. 26) is an especially mysterious work. While Rowe may or may not have known of ancient Egyptian deities or of vodun practices, there is a hint of survival culture. The cow in the drawing recalls the cosmic cow interpreted as "Mother of All," creator of the universe. In ancient Egypt, the cow deity Hathor, associated with fertility, appears in many guises, sometimes with a female body and

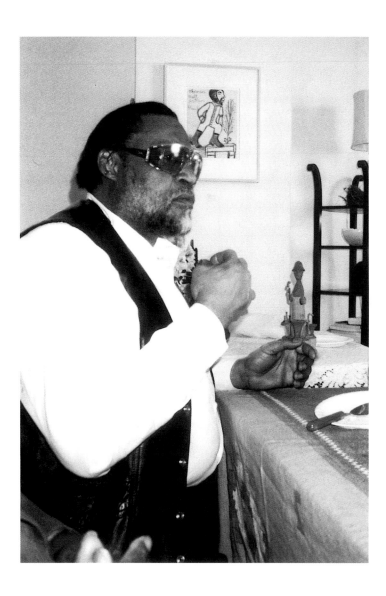

more than twenty children in the Atlanta area be-
tween 1979 and 1981—news that rocked the nation
until Wayne Williams was finally captured—Rowe
created several notable artworks to ward off the
perpetrator(s) and protect the children. The artist
was very secretive about these paintings during the
scare. *Atlanta's Missing Children* hung on Rowe's screen
door. The work features a woman/bird hybrid in a
striped headdress. An intense expression and small
clawlike appendages suggest ferocity. While Rowe
was a devout Christian, this painting, with its refer-
ence to the magical powers of conjurers, clearly was
intended to dissipate the fear that gripped the At-
lanta community and to bring closure to the tragic
events that paralyzed the city. This work hints at the
potency of spirits and possesses vernacular religious
elements that include protective charms. Images
such as a mojo hand, a happy mother and child,
and a small black dog in a diamond-shaped con-
figuration resembling an African cosmogram—all
encased in squares as in *minkisi* (African protective
charms)—resonate with Afro-Caribbean and vodun
beliefs.[39]

Although Rowe never dwelled on the harsh-
ness of her life, *I Will Take You to the Market* (no. 64)
suggests the cruelty of slavery. In the midst of an
exotic landscape reminiscent of nineteenth-century
French painter Henri Rousseau, Rowe places a
huddled, nude figure. Is this a reference to the
slavery and indignities wrought upon African
American women for centuries? Is she alluding
to prostitution, which lures African American
women by economic necessity? The ambiguity of
this picture allows for levels of meaning and con-
tent beyond its lush pictorial surface.

Rowe also draws from popular culture for
her works about African American celebrities,
works that depict high points in the African
American experience. Rowe drew portraits of
noted blind jazz pianist Ray Charles and of the
hirsute, muscular wrestler from the 1970s Claud
"Thunderbolt" Patterson. Rowe's small drawing
of Patterson (no. 6) pictured in profile, in a
jumpsuit, with one leg elevated, captures the
confidence of the champion.[40]

a cow head. Woman/cow deities are cited in Hai-
tian vodun as well. The drawing suggests the power,
strength, and mystery associated with women.
Moreover, in African American slang, women were
sometimes referred to as "heifers."[38] *Green Parrot*
(no. 44), another hybrid creature, is reminiscent
of some of the wildly imaginative dream images of
artist Marc Chagall. In Rowe's painting, a figure
with the head of a woman and the body of a bird
stands in an exotic red forest. The lush landscape
is contrasted with bright white astral light. The
collared domesticated bird is central and domi-
nates a male foreground figure and a small bird in
a background tree. Rowe's inversion of scale be-
tween the foreground and midground figures adds
a dimension of surprise.

The dynamic qualities of these hybrid crea-
tures are explored in *Atlanta's Missing Children* (no. 59).
Moved by the sexual molestation and murder of

22

Throughout her career, Rowe developed a consistent vocabulary of form. Most animals in Rowe's drawings are native to the southern landscape and farm. These creatures may be understood descriptively in this context, but the artist imbues them with simultaneous voices, a double consciousness as they become part of a free, indirect discourse that the author Henry Louis Gates Jr. identifies in *The Signifying Monkey*.[41] Among the most ubiquitous are the fish and the dog, animals Rowe knew from childhood. The fish suggests the "powers of generation and rebirth" and represents the first signs of animal life. The fish is also a metaphor for the wisdom of women.[42] Rowe may have been familiar with ancient mythology through folktales, but she certainly knew the New Testament, wherein fish are associated with Jesus' miraculous feeding of the multitudes. Rowe's fish are often speckled and dotted, full and fecund, suggesting procreative powers, possibly reflecting her own subconscious interest in childbearing, which she longed for but never experienced. Rowe's fish are generally in space or on land, not in water.

Man's best friend, the dog, appears in many Rowe artworks as a guardian figure, a companion, or a whimsical creature, endowed with wistfulness, curiosity, ferocity, and spiritual power. The dog was believed to transport the dead to the underworld as in *I Have a Ride at Last* (no. 80) and has been described as a spiritual mediator.[43] In *Untitled (Dog)* (no. 81), a dog in profile appears heraldic, a fitting counterpart to the magical cow in *Cow Jump over the Mone* (no. 26). The dog also stands for humans, clothed and conversing with other animals or persons. *I Will Sea You at the Rafter Some Sweat Day* (no. 16) features a large humorous dog in front of a building. Dogs were, according to Rowe, "always standing around."[44] The dog in this work overshadows the conversing figures, huddled close together and off to one side. In *Woman Scolding Her Companion* (no. 71), the chastised-looking animal may be a human disguised as a dog, or the artist herself. Likewise, in *Untitled (Woman and Black Dog)* (no. 48), the dog may be human, as it appears to converse with the woman. In *City Dog* (1981), a solitary dog is placed centrally against the urban landscape. Dignified and alone, he seems up to life's challenge. Like self-taught artist Thornton Dial, who used the tiger to represent the black man, Rowe in this work seems to use the dog as a metaphor for African Americans, who migrated to urban areas during the Depression. The dog fends for himself.

Dogs are a predominant subject in the drawings of Rowe's final years. Rowe did not own a dog, but she used the dog metaphor autobiographically to express her many moods as she faced death. Rowe never lost her sense of humor, and she placed an amusing toque on the head of one of her soulful dogs. The expressions on the dogs' faces in 1981 and 1982 shift from surprise to worry and finally to resignation. As the artist's health spiraled downward, texts in dog drawings included "I am Worrie," "I Might Not Come Back," and "I'm Own the Wrong Road." In a small, untitled late work, a woman's head appears on a dog's body, visually merging the two forms.

Rowe claimed that she did not care for dogs, but in interviews she spoke affectionately about Molly, one of the mules on her parents' farm. The mule may have had special significance for the childless artist since, as a cross between a horse and a donkey, it cannot reproduce. Zora Neale Hurston describes a black woman as "the mule of the world,"[45] and in the Langston Hughes poem "I'm like that old mule—/Black—and don't give a damn!/ You got to take me/Like I Am,"[46] the mule is given a strong independent voice. The mule, integral to farmwork, appears in Rowe's drawings as the central subject and as a compositional element. The mule in *Molly* (no. 38) stands against an elaborate quilt in the background. In the compositional masterpiece *Untitled* (no. 47), the mule is centrally placed and appears solid, yet graceful. In this work, complex situations involve people, an occasional hybrid creature, and an undulating snake within a rich landscape. The work—with possible multiple appearances of the artist—exudes tenderness, love, and temptation.

Birds appear in Rowe's paintings in many forms. Rowe featured the eagle with outstretched

wings, signifying freedom. *If You Want to Be Seen . . .* (no. 60) and *When the Eagle Flies* (no. 68) show birds, humanlike and smiling, on the ascent. Referring both to money and to physical power, the eagle represents independence and self-determination. Rowe's *Blue Bird* (1980), a succulent worm in its beak, is adjacent to a fantastically patterned tree in an intricately patterned landscape. Birds such as *Green Parrot* (no. 44) and *Untitled (Orange Tree/White Socks)* (no. 45) continue Rowe's fantastic aviary.

Similarly, the butterfly has special significance in Rowe's work. The butterfly symbolizes the resurrection of Christ and, by extension, the promise of resurrection for all. The butterfly's metamorphosis from caterpillar to chrysalis to butterfly would surely appeal to any artist who would use everyday "trash" to transform her environment. In *Butterfly/ Bird/Woman* (no. 70), the vividly colored, almost frenetic figure wears a red butterfly hat and butterfly bodice and, at the same time, displays the lower body of a bird or chicken in high heels. Less fantastic is the figure (perhaps the artist) in *2041 Paces Ferry Road, Vinings* (no. 35) wearing a butterfly hat that harmonizes with the soft colors of the surrounding elements.

As discussed previously, the artist frequently included detached body parts, especially hands and feet, and sometimes a head in her pictures. The outstretched hand is symbolic of God's blessing, as in *Peace* (no. 21); the foot is symbolic of humility and servitude, as in *Nellie Mae Making It to Church Barefoot* (no. 25). Rowe referred to body parts in the texts of her drawings and explained, "That's my feet to walk with, my hands to work with, my little heart to give love."[47] Her inclusion of a boot or a head in drawings is consonant with vodun practices and beliefs. Deconstruction of body parts inspires both "horror and awe."[48] Isolated body parts are powerful and frightening. Speaking of the large heads on her figures, out of scale with the rest of the body, Rowe called the head the carrier of knowledge. According to West African beliefs, the head is a focus of power. In *I Will Go & See the Dennest* [Dentist] (1979), the oversize head highlights the pain, but while the emphasis on feet in

If You Ar on You Way to the Moon I Will Try the Sun (no. 77) suggests aching feet, why they are exaggerated remains ambiguous.

The raised hands in *Peace* (no. 21) are a Rowe signature. She once said, "I leave my hand, just like you leave your hand on the wall. When I'm gone they can see a print of my hand. I love that—to see a print of my hand. I'll be gone to rest, but they can look back and say 'that is Nellie Mae's hand.'"[49] She encouraged her nieces and nephews, after tracing each one's hand, to personalize their hands with nails, rings, and watches.[50] In the gospel church service, the raised hand from congregants symbolizes faith and understanding. In *Peace,* two black hands with polished nails and matching red wristwatch are raised protectively in front of a guileless blue dog/lamb. The color blue recalls the African American custom of painting blue around house doorways for protection. A variation on the hands is footprints, prominent in *Nellie Mae Making It to Church Barefoot* (no. 25). Here, two footprints dominate the lower portion of the work. The family lived about three miles from Flat Rock, and although they owned a horse and buggy, Rowe usually walked to school and church.

Plants and trees abound in Rowe's vocabulary. Almost every culture and religion has embraced the tree as a symbol for life, as in *Tree of Life* (no. 29). The abundance of trees in Rowe's own environment and the pervasiveness of the outstretched branches in her work are striking. A fantastic plant in *Untitled (Plant)* (no. 52) takes on life-giving power and suggests female anatomy with its huge womblike root source of colorful, concentric circles on a chairlike leg framework.[51] An encased dog and bird seem to derive succor from the dazzling plant/tree. A plain gray-purple background highlights the foreground, decorated with small rosettes. A white bird or dog stares contentedly from the bottom foreground, calling the viewer's attention to the remarkable sight.

Rowe uses many of her recurrent images to refer to sexuality. In *Payhouse [Playhouse]* (no. 67), a signature work, the artist depicts herself drawing a tree of life in front of her house. She is seated

below a large, hovering, doglike figure with a distinctly phallic head. The huge tree shaped like a vagina emphasizes the female nature of the scenario. In two works (nos. 42 and 43), Rowe features intense and emotional seductresses centrally placed and in control. In no. 42, the central figure meets the viewer's gaze with a smile. In no. 43, a guardian dog waits at the feet of a red figure, who is turned away from the spotlight. The female figure is enveloped in a fallopian tube–like element that alludes to fertility, as does the hen nesting on a multitude of eggs.[52] In *Butterfly/Bird/Woman* (no. 70), the bright red figure has a strong feminine anatomy. The main character, with a beguiling grin, looks at first like a costumed Josephine Baker giving a performance. On closer observation, the painting reveals surprising transformational shifts between the woman and a butterfly. Love and affection come through in an untitled work (no. 20), *Harlem* (no. 53), and *This Is Vinings Mounton Hawk Watch* (no. 37). In no. 20, the sexual orientation of the figures is ambiguous; they may be "kissing friends" like Janie and Pheoby, characters in Hurston's novel *Their Eyes Were Watching God.* The pleasure of couples interacting and animals nesting is evident in numerous works. Birds peck at animals and people. In *Untitled* (no. 50), a phallic form metamorphosed from a female torso seems to penetrate a womblike cavity that is also the arched back of a bird. In *Alligator Man* (no. 19) a high-stepping man has just left a reclining woman. In *Full Moon* (no. 63), a nude woman in yellow is an enticing presence in a red-toned landscape. Full, ripened fruit may be read as women's breasts. The orange breastlike fruit of a distinctly sensual tree is featured in *Untitled (Orange Tree/White Socks)* (no. 45). The central figure is once again of ambiguous sexuality. The hot-orange fruit seems to send off a perfumed fragrance, and the masked figure, the magical bird, and the tree laden with fruit all combine in an atmosphere not unlike the Chagall sets for the forest scene in Mozart's opera *The Magic Flute.*

Quilting was a lifelong hobby of Rowe's and she integrated her quiltlike designs into her artworks.[53] The four-patch pattern used in *What It Is*

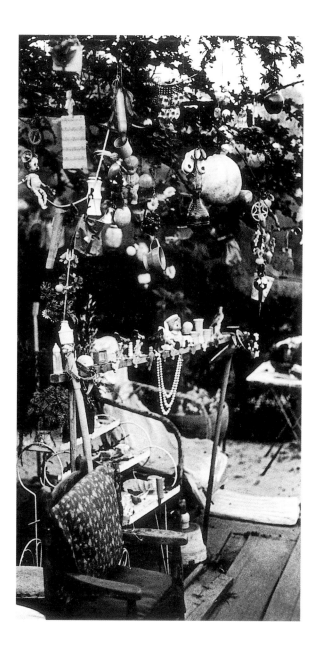

Nellie Mae Rowe's yard, c. 1971

(no. 69) mirrors a four-paned window, enlarged and standing independently on the road of life. The variety of quiltlike patches on the facade of Rowe's house in *Payhouse [Playhouse]* (no. 67) are important. Rowe embellishes windows, doors, and walkways with improvisational quilt elements, such as four- and six-patch patterns, strip horizontal piecing, lozenge motifs (possibly cosmograms), and a radial design. In *Molly* (no. 38), the background is a riot of embellished squares, both four- and two-patch designs. Rowe depicts a veritable portrait gallery of people—both in profile and frontally—animals, and plants within a background of squares. The patterns and colors alternate, and the artist shifts the sizes of the squares. The use of motif, scale, and color varies, creating the spontaneity and

25

improvisation associated with African American quilting and its musical counterpart, jazz.

A final symbol—the chair—has profound cultural and personal significance in Rowe's work. For domestic laborers, chairs provide relief for tired feet and backs. Although so many domestic tasks require standing, Rowe's pictures of women at work frequently show the worker seated. The chair allows Rowe to establish her domain. In African and Afro-Caribbean references, the chair is sometimes described as a throne and is sacred.[54] To Rowe, the chair defined her space, and often Rowe drew herself as an observer of life, seated in her thronelike chair. Photographs of Rowe's yard show chairs for her guests and for herself. The empty chair in her late works has a special poignancy. The

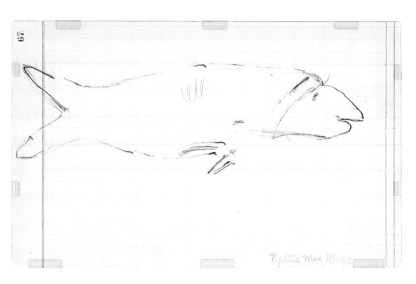

Untitled (Fish),
c. 1950

chair in *Rocking Chair* (no. 75), which is empty, evokes feelings of absence and loss and a premonition of death. The rattan chair in a cozy, well-decorated interior exudes the invisible presence or absence of the sitter—the artist whose spirit pervades the room, but whose physical presence is no longer a reality.

Rowe's artworks seem to have a spontaneous beginning, an almost accidental mark, doodle, or meandering over a surface. In Paul Klee's words, she "took a walk with line."[55] Rowe's freedom with line is evident in such early works as *Something That Ain't Been Born Yet* (no. 4). The artist fully explores the curved line and the softened edge, avoiding sharp angularity. Even the geometric quiltlike de-

signs incorporated into her work are made up of free-form squares, stripes, and patterns. An exception can be seen in Rowe's architectural drawings—*Nellie Mae Rowe's House at Night* (no. 74), *Nellie Mae and Judith's Houses* (no. 41), and *Payhouse [Playhouse]* (no. 67)—where angularity predominates but freehand rather than ruled angles are preferred.

The early works consisted of single images—a dog, a fish, a plant, a tree, a person. Continuing to explore individual subjects, Rowe created a few samplers, in which she brought together a variety of objects in one composition, but each in its own space, united only by subject. Throughout her career, she continued to create works featuring a single dominant image, but these were combined with denser, more complicated related images. In her masterly multifigured works from 1980 and 1981, figures generally interact and merge organically; negative space often invites other forms, and every available space is occupied either by images or decorative patterning or both. The viewer's eye literally dances around the composition at a lively, rhythmical pace. The density of the composition does not disturb the compositional balance. Many of Rowe's final works are sparser, yet are heightened by her technical mastery and her increased understanding of herself.

Perspective did not concern Rowe. Her figures often appear, disappear, and float in space, and the pictorial elements are contained within a shallow picture plane. Simultaneous perspectives seem to offer Rowe, like other self-taught artists, the greatest latitude for presenting information. Liberty with scale allowed the artist to place emphasis where she wanted. Some of her works seem to encompass a vast amount of material, almost as a compressed aerial view. A favorite formal device of the artist is to echo the shapes of individual forms in order to create a pleasing decorative pattern, as in *Untitled (Plant)* (no. 52). Another is to place elements in enclosed spaces and to draw attention to them as they appear protected within themselves, as in *Sleepy Girl* (no. 78). Yet another significant formal technique is a binary device in which two images share a single contiguous contour, as in *Untitled* (no. 47),

26

wherein the torso of a human figure fills the back of a mule, or *2041 Paces Ferry Road, Vinings* (no. 35), in which a woman's profile is shared by the outer wing of a butterfly.

Rowe used the diagonal in her roadway pictures, giving them energy and movement. Her Vinings home was near the intersection of Highways I-75 and I-85, and Rowe uses the road metaphor to show the transformation of her community from a rural pocket to a place with connections to a wider world. *Pig on Expressway* (no. 39) and *Winged Dog on Expressway* (no. 72) capture the spirit of agrarian rural life intersecting with modern technology. In *Pig on Expressway*, the road, with undulating bands of bright color like a free-form quilt pattern, provides a lively view of the modern world, juxtaposed with the solidity of the heavy pig caught in an absurd situation in the middle. In *Expressway* (no. 55), a strong diagonal divides the composition. Beneath the diagonal roadway, a checkerboard pattern suggests the road of life is a vast game of chance. In the midground and background, a dense, compressed, throbbing community of living forms interacts and coexists. The artist as narrator/commentator appears several times, in one instance observing from a chair. The ascending diagonal in Rowe's final works may be interpreted as an ascent on a roadway to heaven.

Asymmetrical balance is achieved in *Conversation* (no. 33). Rowe has mastered space by creating simultaneous and almost dizzying off-balance positioning of the bench and chair from which two people converse. With a background of trees and plants somewhat grounded in space and an animal grazing quietly in the background, this drawing has the rhythm of a musical work. A rope in front suggests the snake in the Garden of Eden. The figures are teetering in their seats and likely to "fall" (pun intended), but they are having such a good time that it probably doesn't matter. The woman, her chair, and the guard dog on her shoulder are rounded like the snake.

Just as Rowe varied her formal elements, she varied the materials she used. She worked on every available surface, including discarded egg crates, Styrofoam trays she found at the supermarket, and, as in *Four Faces* (no. 2), on pressed-paper fruit trays. She preferred paper as a ground and used ink, felt-tip marker, ballpoint pen, graphite, colored pencil, crayon, and gouache. She rarely worked with oil paint. The artist seemed to prefer a palette that featured red, blue, green, yellow, orange, pink, brown, and black. She used deeply saturated colors in high contrast. To use the words of Robert Farris Thompson, the "deliberate, high-effect collisions of color" heighten "bodily incandescence" and contrast with self-possessed facial expressions.[56]

Artistically expressive in several media, Rowe made dolls among her earliest works. Rowe said that dolls—those she made, found, and received—kept her company and were playmates in the "playhouse"; they substituted for the children she never had. To make dolls, Rowe used fabric, yarn, clothing, beads, jewelry, and other accessories, as well as pen, marker, and needle and thread.

Other sculptural forms that seem to manifest strong African or Afro-Caribbean retentions are Rowe's embellished wood objects. The pulsating painted dots on Rowe's *Fish on Spools* and free-form fish, made from precut plywood, illustrate the "flash" thought to signal a linkage between the spiritual and natural worlds.[57] One of the more unusual materials Rowe used was chewing gum, which she fashioned into people, figural busts, and animals, real and imagined. When Rowe suffered from headaches, a physician advised her to chew gum. She discovered she could make art with her discarded Wrigley's and Beechnut gum. After Rowe formed the gum figures and embellished them with beads, marbles, and hair, the works were hardened by refrigeration. Rowe added paint to some of the figures after hardening. Many of the pieces are amusing; others are more ambiguous.

From her earliest works on paper, Rowe introduced a formal vocabulary that she used all her life. Tree, fish, fowl, and human figures stood for the natural world, but almost from the beginning Rowe included fantasy figures. Rowe's earliest renditions of objects and people suggest an attempt at naturalism and realism, but she abandoned this as

27

her confidence and creativity flowered. Her single images gave way to more complex compositions in which reality and fantasy coexist harmoniously. After Rowe's inclusion in "Missing Pieces: Georgia Folk Art 1770–1976," at the Atlanta Historic Society, Rowe was represented by Judith Alexander of the Alexander Gallery in Atlanta. Alexander brought a wide variety of art materials to Rowe's attention. The years 1980 and 1981 saw a major flowering of Rowe's creativity, with many fully developed complex works. Depictions of life on the farm and in the Vinings community, with its houses, roadways, and recreational activities, combine with Rowe's fantastic and spiritual journeys to

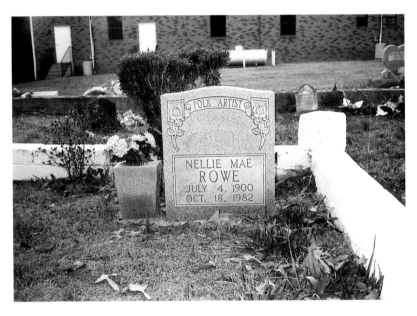

Nellie Mae Rowe grave site, 1997

attest her love of life and her freedom to express herself. Her final works are as strong as her early ones, though more questioning. In a series of pictures from the 1980s, Rowe uses the road metaphor for life. In *What It Is* (no. 69), a vernacular African American greeting, the artist is portrayed as a young woman briskly crossing a road; she is wide-eyed and full-faced, with vines in her hair, open to all of life's possibilities. In the related expressway pictures, the energetic diagonal form is unifying. The dog and road pictures of 1981 and 1982 alternate between a horizontal and diagonal format, the diagonal taking on new meaning as a spiritual road to heaven. Rowe did not own a dog, but in the works of her last two years, the dog cap-

tures her moods as she faces death. One of her last works, *Look Back in Wonder How I Got Over* (no. 83), expresses her ability to overcome her sorrow through faith. The work hints at Rowe's hopes for a successful journey over the Jordan River and a place in heaven. Her triumph and joy are underscored by the choice of brilliant yellow, the color of the sun's rays. The illusion is based on biblical references and a well-known gospel hymn.[58]

Through the force of her personality, innate wisdom, creative vision, and technical virtuosity, Rowe communicated in a profound way. She faced challenges of race and gender, she experienced years of economic hardship and physical pain, she loved children but remained childless, and she lost two husbands. But her indomitable spirit and internal feeling of liberation transcended the obstacles life offered. Her understanding of herself as a woman and as a human being was both natural and accepting, and her humor was unfailing. She achieved financial security in her last years through the sale of her art and experienced happiness through self-expression, religious faith, and recognition as an artist. In 1989, Nellie Mae Rowe was noted, along with Frida Kahlo, Edmonia Lewis, Louise Nevelson, Georgia O'Keeffe, and others, by the Guerilla Girls, a group of artists and art professionals.[59]

Paralleling African American literary traditions of free indirect discourse, Rowe projected thoughts and emotions through animals, plants, even chairs—anything that gave vibrancy and immediacy to her expression. Rowe's work, which combines nostalgic reminiscences, fantastic journeys, deep spirituality, and emotional intensity, ensures her a significant place in art history.

NOTES

1. Biographical information was taken from a series of interviews with Judith Alexander and with the artist's family and friends by the author, conducted from 1994 to 1998. Judith Alexander provided tapes of additional interviews with Rowe and her family and friends. These tapes were recorded over several years by several interviewers.

2. James Baldwin, "The Price of the Ticket," in *The Price of the Ticket: Collected Nonfiction, 1948–1985* (New York: St. Martin's/ Marek, 1985). Quoted in Johnetta B. Cole, *Conversations: Straight Talk with America's Sister President* (New York: Anchor Books, 1993), p. 2.

3. Cole, *Conversations*, p. 3.

4. Gilbert J. Rose, M.D., *Necessary Illusion: Artist as Witness* (Madison, Conn.: International Universities Press, 1996), pp. 15–16.

5. Death Certificate. Vital Records Service, Georgia Department of Human Resources, Atlanta, May 23, 1996.

6. Melvin Smith, in *Neither More nor Less Than Men: Slavery in Georgia: A Documentary History,* ed. Mills Lane (Savannah, Ga.: Beehive Press, 1993), p. 196. Smith recalls slavery days and that food for slaves was commonly poured into troughs.

7. This was a family of mostly girls, and it was a family custom to give the girls boys' names. Clara was named Tom, Elnora was named Jim, and Minerva was named Bob.

8. This poem, copied in Rowe's handwriting on a scrap of paper, was discovered by Xenia Zed as she examined Rowe's archival material. There is no author indicated.

9. Platt map of Vinings properties around and including Rowe house. Cobb County Courthouse Tax Assessor's Office, L.L. 885–17–2 section 886.

10. Judith Alexander, *Nellie Mae Rowe: Visionary Artist, 1900–1982* (Atlanta: Southern Arts Federation, 1983), p. 9.

11. Atlanta historian Franklin Garrett, interview with the author, May 29, 1998; Joe Brown Sr., interview with the author, July 22, 1998.

12. Folk art scholar Ben Apfelbaum and Claud "Thunderbolt" Patterson, interview with the author, January 14, 1998.

13. *Nellie's Playhouse,* prod. and dir. Linda Connelly Armstrong, 13 min., Center for Southern Folklore, Memphis, 1983, videocassette.

14. Anna Wadsworth, *Missing Pieces: Georgia Folk Art 1770–1976* (Atlanta: Georgia Council for the Arts and Humanities, 1976), p. 52.

15. Grey Gundaker, "Tradition and Innovation in African-American Yards," *African Arts* 26 (April 1993): 59.

16. Ibid., p. 71.

17. Robert Farris Thompson, afterword, in *Recycled, Re-Seen: Folk Art from the Global Scrap Heap,* ed. Charlene Cerny and Suzanne Seriff (New York: Harry N. Abrams in association with the Museum of International Folk Art, Santa Fe, 1996), p. 181.

18. Ibid., p. 182.

19. Richard Westmacott, *African-American Gardens and Yards in the Rural South* (Knoxville: University of Tennessee Press, 1992), pp. 1, 2.

20. Gundaker, "Tradition and Innovation," pp. 60, 63–66. Gundaker here refers to a study of slave culture by Dell Upton.

21. Robert Farris Thompson, "An Introduction to Transatlantic Black Art History: Remarks in Anticipation of a Coming Golden Age of Afro-Americana," in *Discovering Afro-America,* ed. Roger D. Abrahams and John F. Szwed (Leiden, Netherlands: E.J. Brill, 1975), pp. 62–63.

22. Grey Gundaker, "'Face Like a Looking Glass': Countenance, Cosmology, and Transformation," in *"More Than Cool Reason": Black Responses to Enslavement, Exile, and Resettlement* (Haifa, Israel: University of Haifa, 1998), p. 8.

23. Westmacott, *African-American Gardens and Yards,* pp. 79–82.

24. Ibid., p. 80.

25. Cathy Perry, interview with the author, December 27, 1997. For a discussion of carpet in yards, see Westmacott, *African-American Gardens and Yards,* p. 48.

26. Gundaker, "Tradition and Innovation," p. 59.

27. Perry.

28. Variations of these lyrics have been recorded in a number of gospel songs, such as: "I'm Going to Telephone to Glory" (Heavenly Gospel Singers, 1936); "Ain't Gonna Lay My Receiver Down" (Mitchell's Christian Singers, 1938); "The Royal Telephone" (Christian and Missionary Alliance Gospel Singers, 1923; Blind Connie Rosemond, 1927; Rev. Sister Mary M. Nelson, 1927; and Selah Jubilee Singers, 1939); and "Operator" (Sterling Jubilee Singers, 1993). This information was provided by Russell Scholl from his extensive collection of recordings.

29. "What Can I Do?/Hush, Hush, Somebody's Calling My Name," Quincy Jones ("Roots" television series soundtrack, 1977); "Hush! Somebody's callin' my name," Jessye Norman ("Spirituals," Phillips, CD416 462-2, no. 13, 1987); The Sandhills Sixteen (Victor cat. no. 20904), late 1920s; and The Blind Boys of Alabama ("I Brought Him With Me," House of Blues, 700108 7003, 1996).

30. Eleanor Shropshire purchased the plaques at a tourist gift shop during a vacation to Myrtle Beach, South Carolina. Interview with the author, January 1998.

31. Clarence Major, ed., *Juba to Jive: A Dictionary of African-American Slang* (New York: Penguin Books, 1994), p. 379.

32. Robert E. Hemenway in *Zora Neale Hurston: A Literary Biography* (Urbana: University of Illinois Press, 1977) points out that Sonia Sanchez's book of poetry entitled *We a BaddDDD People* is similarly "reversing the moral dialogue by being true to the linguistic traditions of her race," p. 224. See also Major, pp. 15–16.

33. Dan Rose, "Detachment: Continuities of Sensibility among Afro-American Populations of the Circum-Atlantic Fringe," *Journal of Asian and African Studies* 9, nos. 3–4 (July–October 1974), pp. 202–216.

34. Donald J. Cosentino, ed., *Sacred Arts of Haitian Vodou* (Los Angeles: UCLA Fowler Museum of Cultural History, 1995), p. 67.

35. Donald J. Cosentino, *Vodou Things: The Art of Pierrot Barra and Marie Cassaise* (Jackson, Miss.: University Press of Mississippi, 1998), p. 20.

36. Perry.

37. Cosentino, *Sacred Arts*, p. 56.

38. Vinings resident L.C. Mitchum spoke of women as "heifers." In Clarence Major, *Juba to Jive*, p. 229, "heifer" is identified as a disparaging reference to a woman. The term refers to a woman who "refuses to conform to prescribed proper behavior."

39. For a discussion of such survivals see Robert Farris Thompson, *Flash of the Spirit: African and Afro-American Art and Philosophy* (New York: Vintage Books, 1983).

40. Patterson held the Georgia television title twice, in 1978 and 1979, and with Ole Anderson as his partner, they held the prestigious Georgia National Tag Team Belts. See *Biographical Dictionary of Professional Wrestling* (Jefferson, N.C.: McFarland & Co., 1997).

41. Henry Louis Gates Jr., *The Signifying Monkey: A Theory of Afro-American Literary Criticism* (New York: Oxford University Press, 1988), pp. 207–210. While Gates describes a literary method, Rowe "speaks" visually and indirectly.

42. Buffie Johnson, *Lady of the Beasts: Ancient Images of the Goddess and Her Sacred Animals* (San Francisco: Harper & Row, 1988), p. 224.

43. Gundaker, "'Face Like a Looking Glass,'" p. 8.

44. Judith Alexander, interview with the author, May 6, 1998.

45. Zora Neale Hurston, *Their Eyes Were Watching God* (New York: Perennial Library, 1937), p. 14.

46. Langston Hughes, "Me and the Mule," in *The Collected Poems of Langston Hughes*, ed. Arnold Rampersad (New York: Vintage Books, 1994), p. 239.

47. Nellie Mae Rowe, interview with Judith Alexander, August 1982.

48. Cosentino, *Vodou Things*, p. 17.

49. Alexander, *Nellie Mae Rowe*, p. 11.

50. Perry.

51. Gundaker, "Tradition and Innovation," p. 70.

52. Rowe often spoke of her childlessness and desire to have children.

53. Maude Southwell Wahlman, *Signs and Symbols: African Images in African-American Quilts* (New York: Studio Books in association with the Museum of American Folk Art, 1993). The relationship of Rowe's quilt elements to African American quilts is striking. The entire book is relevant.

54. Suzanne Blier, quoted in Cosentino, *Vodou Things*, p. 19.

55. Paul Klee, quoted in Sylvan Barnet, *A Short Guide to Writing about Art* (New York: HarperCollins, 1993), p. 28.

56. Thompson, "An Introduction to Transatlantic Black Art History," pp. 66–67.

57. Robert Farris Thompson, interview with the author, spring 1989.

58. Variant titles of this gospel song are "My Soul Looks Back" (Marion Williams, 1992) and "How I Got Over" (The Fairfield Four, 1953; Mahalia Jackson, 1961; Sumner Quintet, 1966; and Richard Allen Singers, 1991). This information was provided by Russell Scholl.

59. The Guerilla Girls, *The Guerilla Girls' Bedside Companion to the History of Western Art* (New York: Penguin Books, 1998), p. 90. The Guerilla Girls, a group of contemporary feminist artists and art professionals, include Nellie Mae Rowe in their list of great women artists.

ROWE SPEAKS

The following words are Nellie Mae Rowe's. Unless otherwise noted, they have been transcribed from tapes in the collection of Judith Alexander.

What is surprisin' and makes me feel good is to think about people I would never have seen, if I had not been doin' things like this that was interestin' to them. And it is interestin' to me to see them while here on this earth.

I'm back to a child again. I'm seventy-five years old and I'm like a child. I get a kick out of drawin'. If I had the opportunity that children have now, I don't know what I would have done. I ain't had the opportunity. I had to go to the fields. Children now when they come from school they can go and play. When we came from school, we had to put our sacks on and if it wasn't cotton, you had to pick peas. If it wasn't peas, it was pull corn. If it wasn't corn, it was pull fodder. If it wasn't fodder, it was strip sorghum cane. Weren't that, haul the sweet potatoes. Wasn't time for potatoes, you have to go shell the peas. There is somethin' to do all the time. Now it is time for me to rest and play. I've worked my days, now I want to play these other days out. And God will let me do it, too. I'm goin' to play in my playhouse. I love it!
—Videotape by Charles Brown, Charleston Communication Center

You see a bird, he is way up in the air flyin', but when he gets ready to light he has to come back to the ground. So that's me. I'm on the ground, and I'm goin' to stay here. I may go up a little bit but I'm not goin' to fly so high I can't get back to the ground. That is the life I am livin'.

Sometimes I dream in my sleep and I forget about it time the day come, but sometimes I will get up through the night and make a start of what I've done seen 'cause if you don't, you'll forget how it looks the next mornin' and it is just like a dream when I see those things I drew. I don't know what they are by name myself. People say, "Nellie, what's that?" I don't know what it is, but I know one thing: it is in my mind. I draw things you ain't never seen born into the world and they ain't been born yet. They will be seen someday, but I will be gone.

I feel great bein' an artist.

I didn't even know that I would ever come to be an artist.

It is just surprisin' to me.

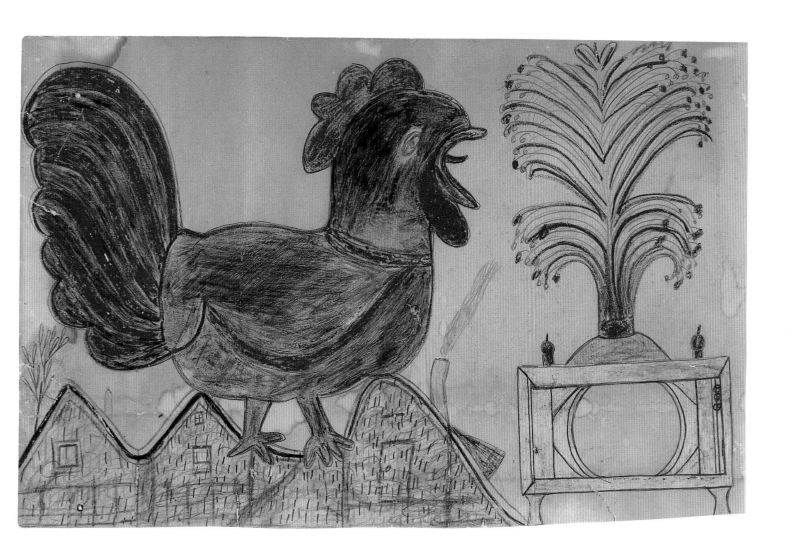

Green Rooster *c. 1972*

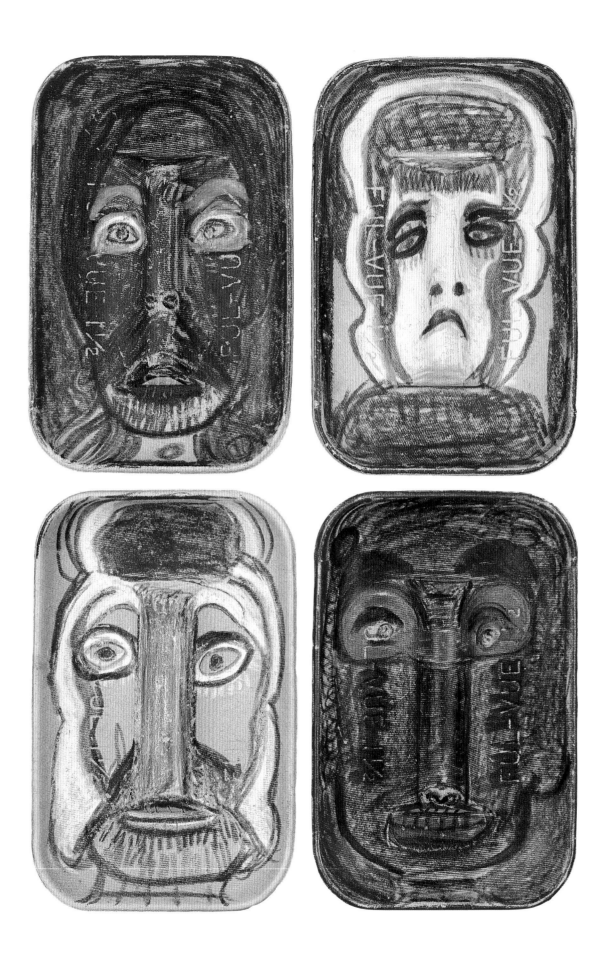

Four Faces c. 1972

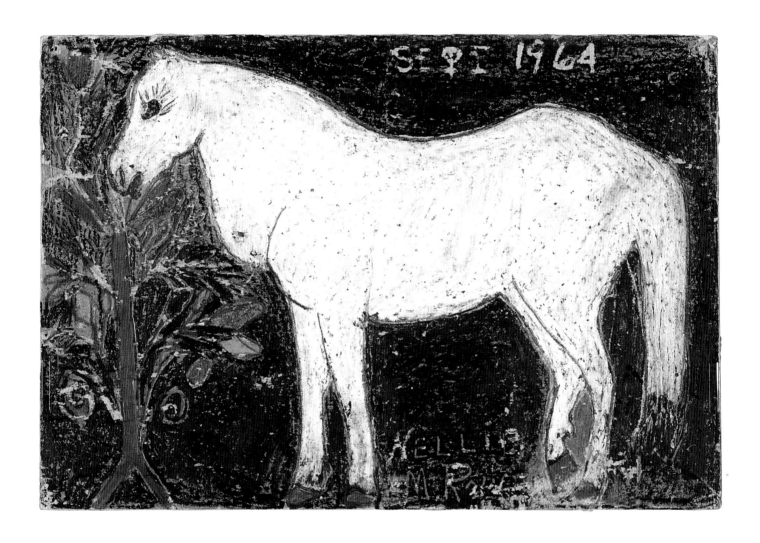

White Horse *1964*

260

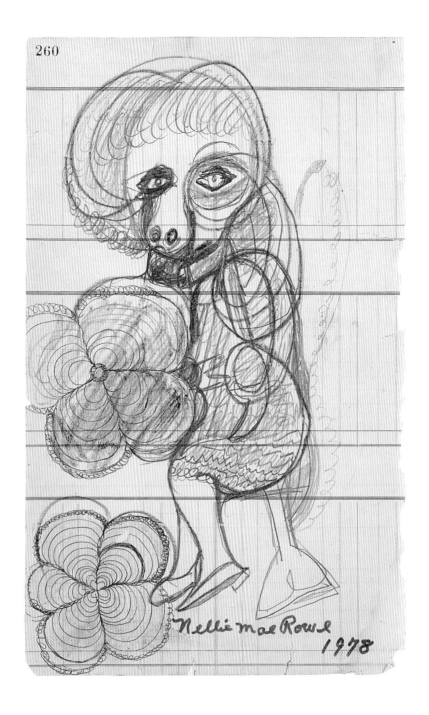

Something That Ain't Been Born Yet *1978*

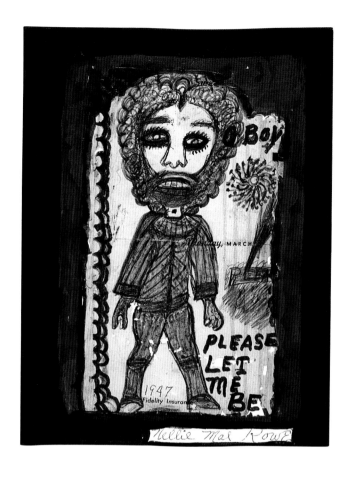

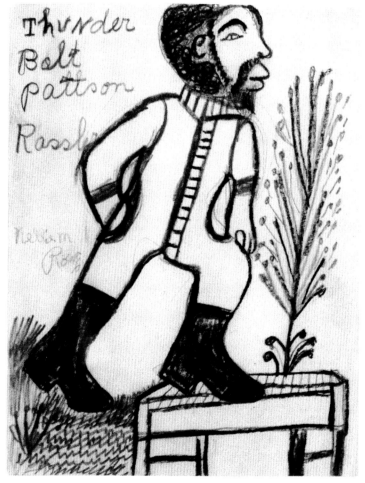

Please Let Me Be *Dated 1947 [1974?]*
Thunder Bolt Pattson [Patterson] Rassler *c. 1975*

All my dolls, chewin' gum sculptures,
everythin' will be somethin'
to remember Nellie.
If you will remember me,
I will be glad and happy
to know that people have somethin'
to remember me by
when I have gone to rest.

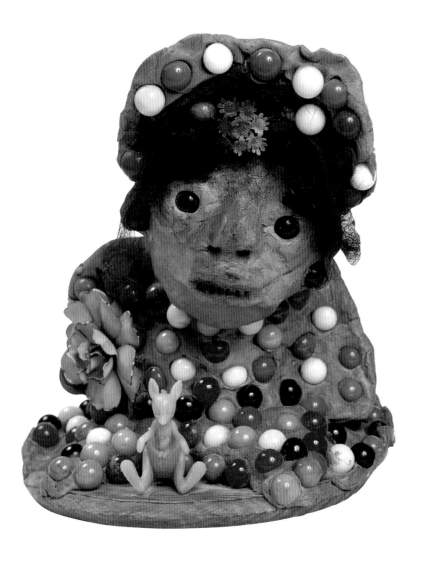

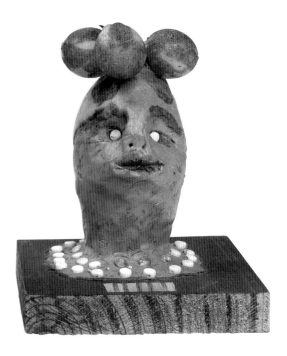

Woman (Chewing Gum Sculpture) c. 1972
Head (Chewing Gum Sculpture) c. 1981

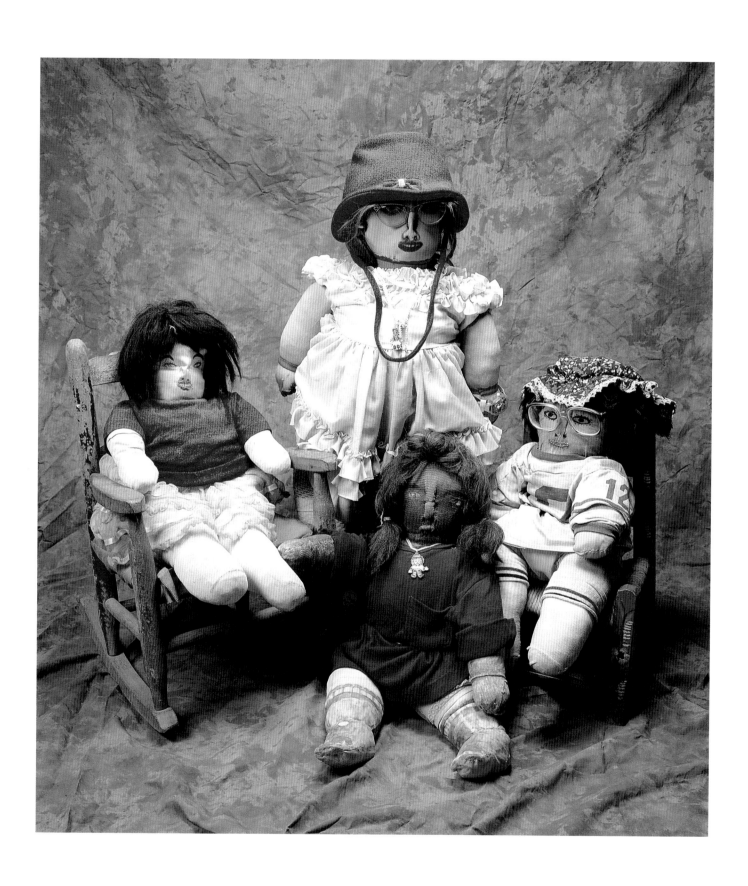

9-12 TOP Handsewn Doll *c. 1981* RIGHT Handsewn Doll *c. 1974*
BOTTOM Handsewn Doll *c. 1980* LEFT Handsewn Doll *c. 1980*

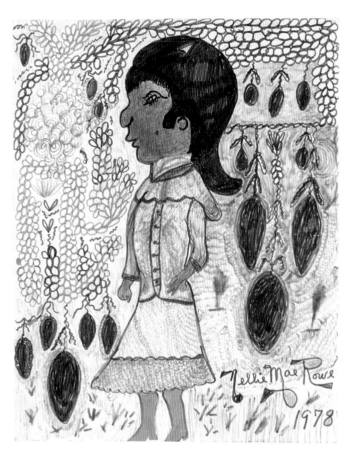

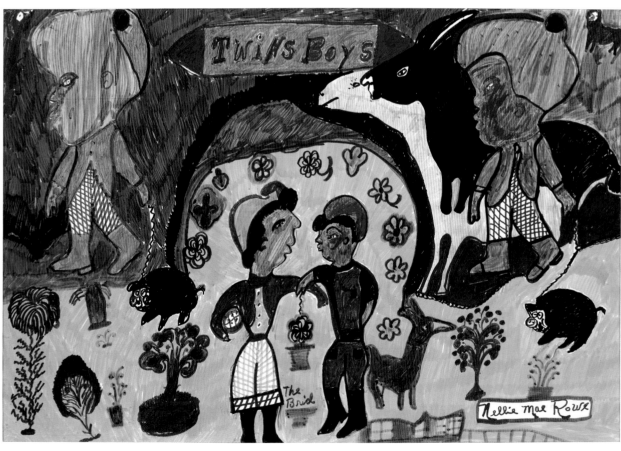

Untitled (Girl in Blue) *1978*

Twins Boys *1978*

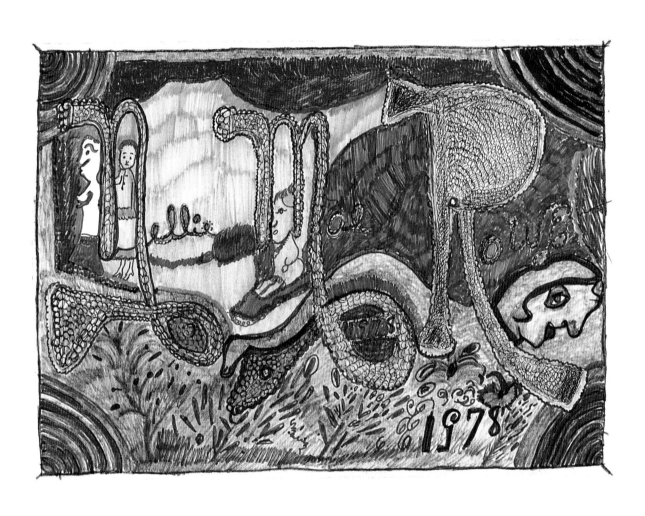

Nellie Mae Rowe *1978*

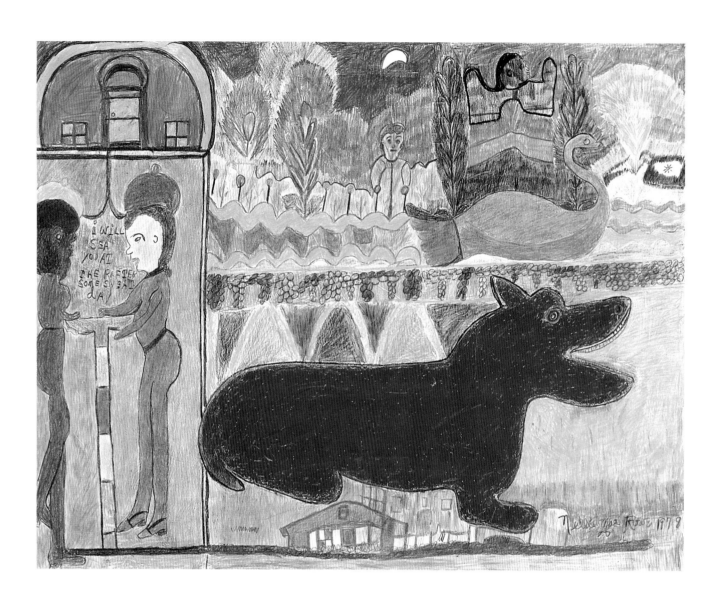

I Will Sea You at the Rafter Some Sweat Day *1978*

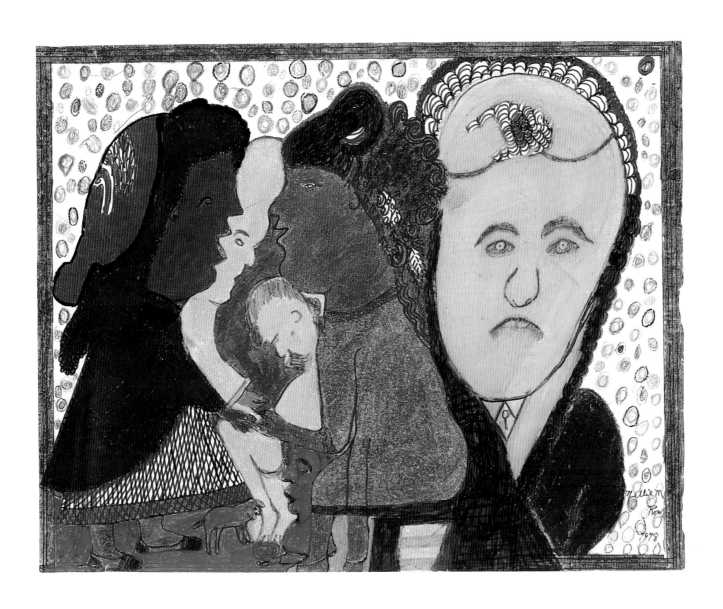

Humpy [Humphrey] *1978*

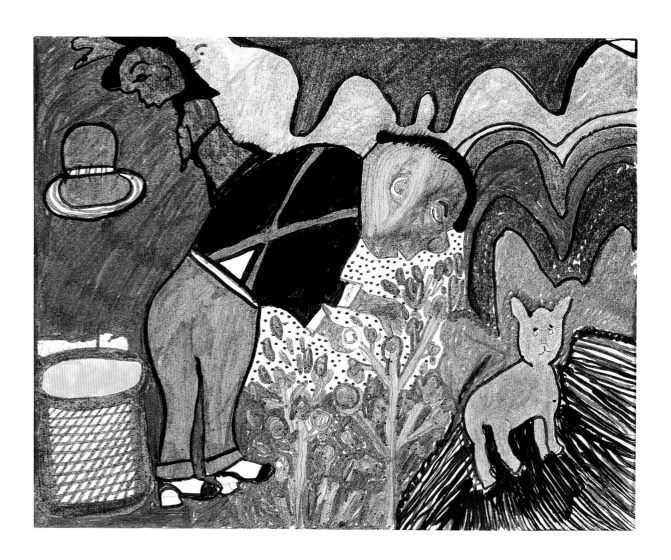

Picking Cotton *1978*

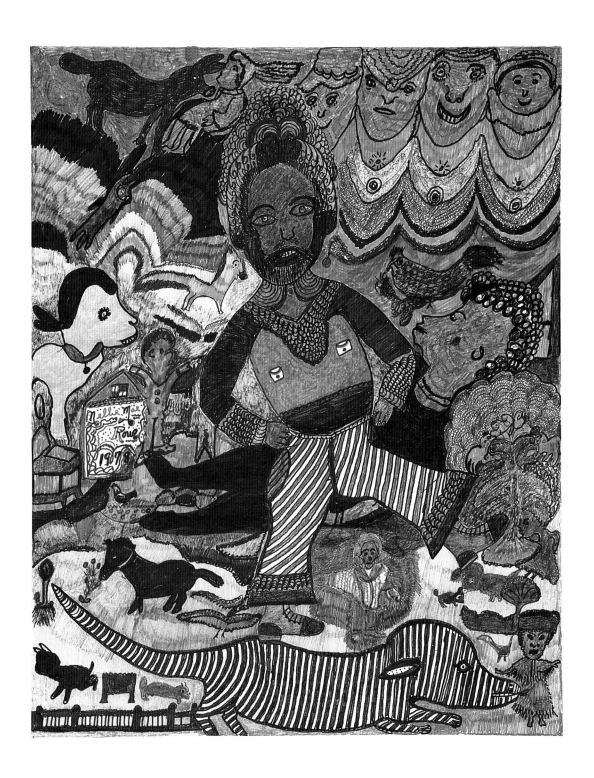

19 Alligator Man *1978*

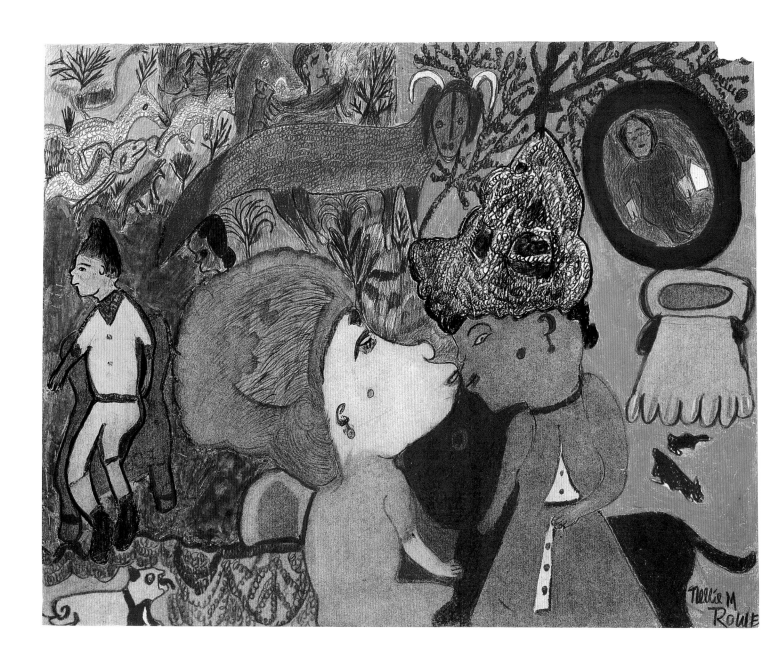

20 Untitled 1978

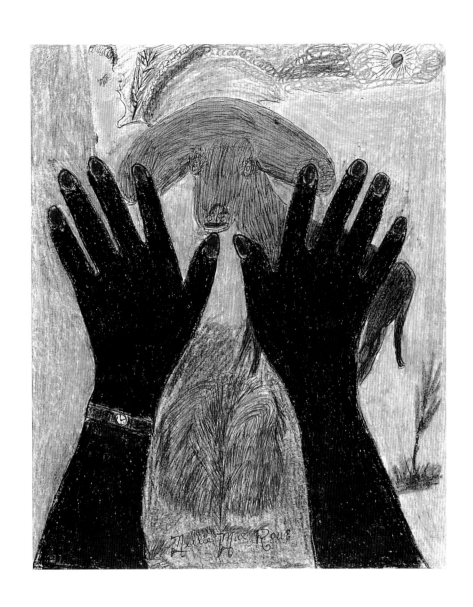

21 Peace 1978

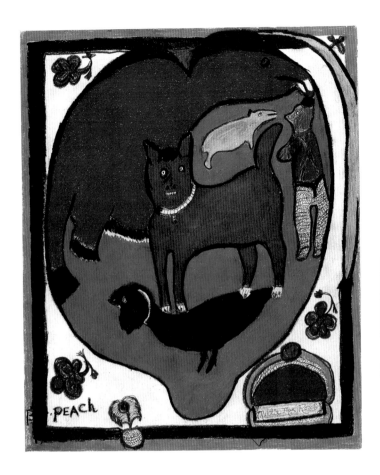

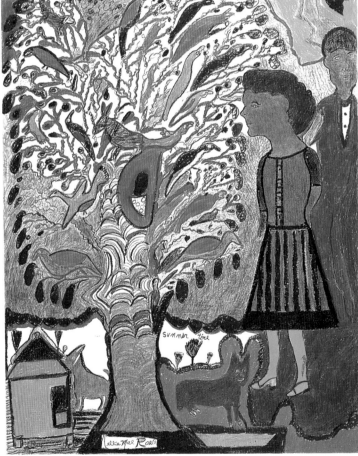

Peach *1979*
Summer Time *1979*

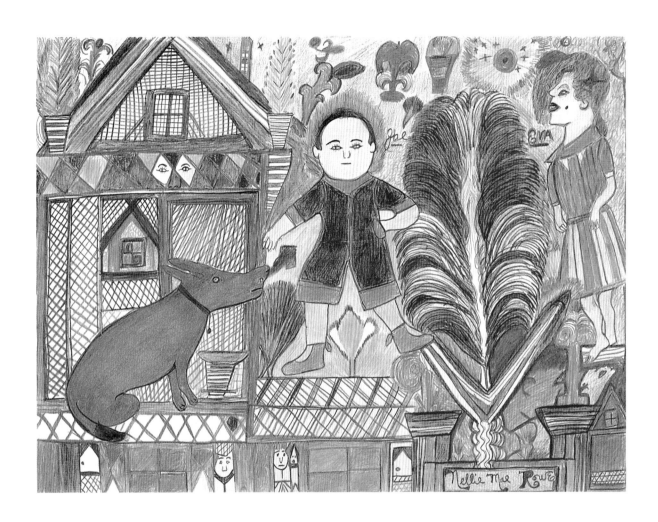

24 Joe and Eva *1979*

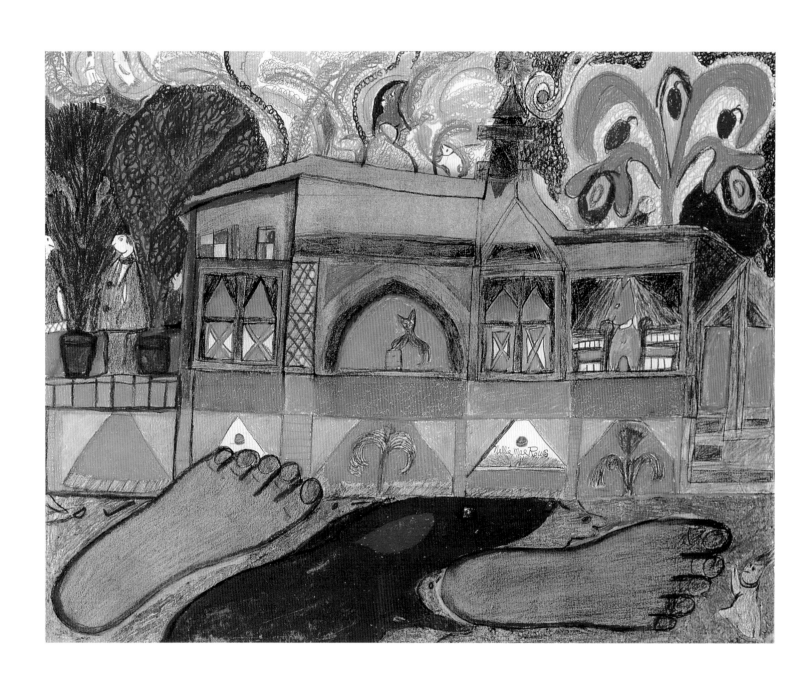

Nellie Mae Making It to Church Barefoot *1978*

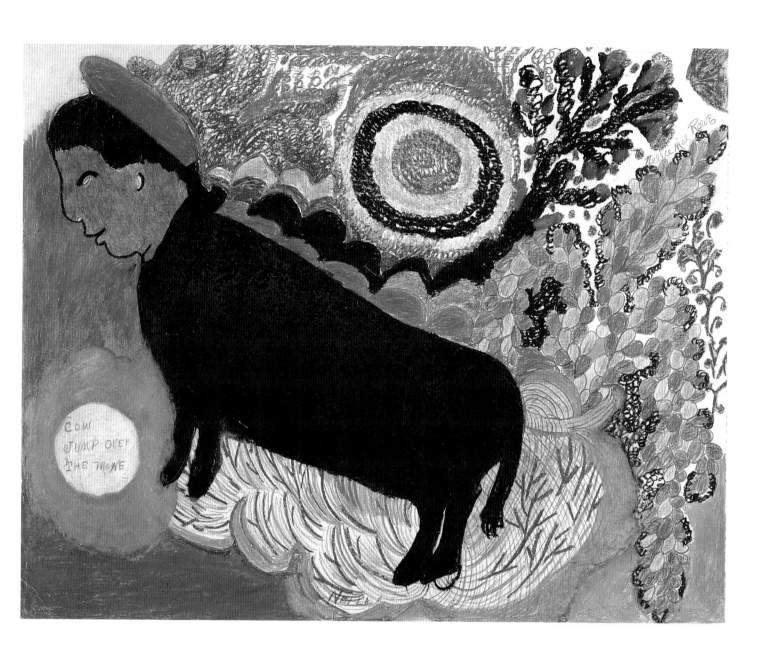

Cow Jump over the Mone *1978*

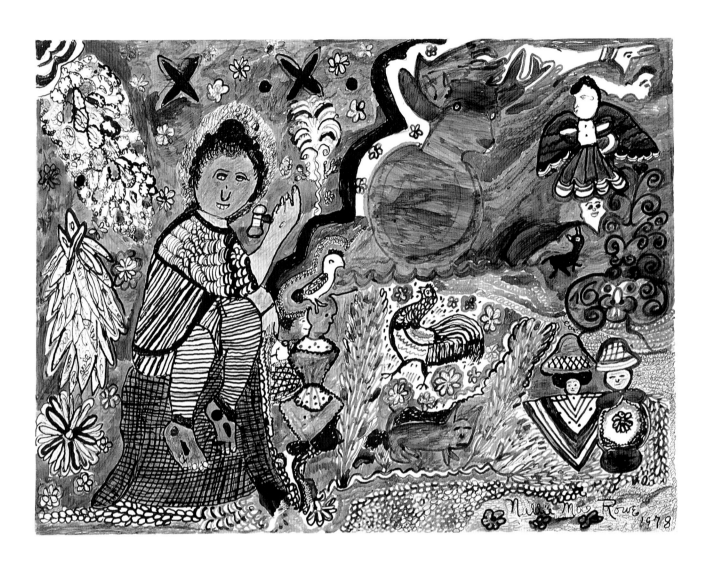

Haints *1978*

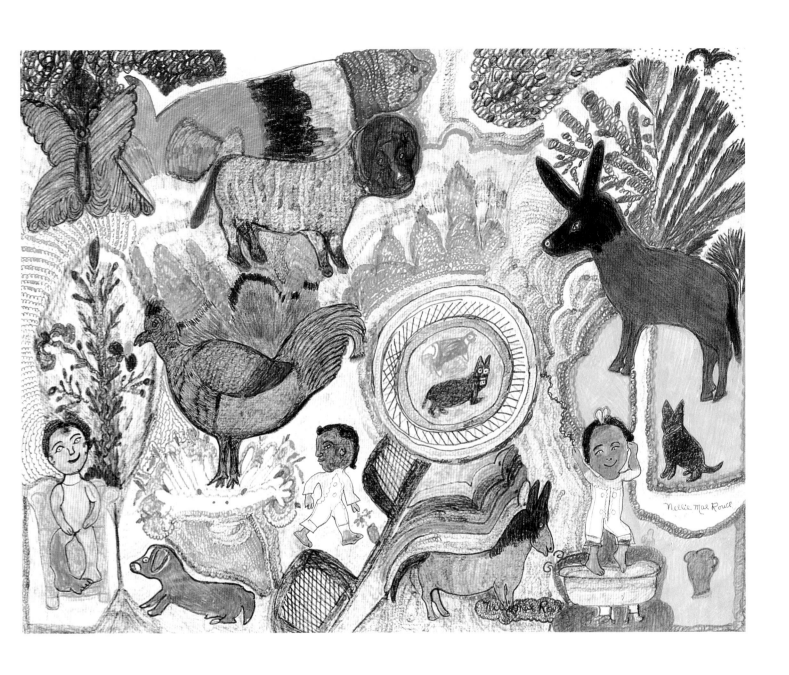

28 Creation 1979

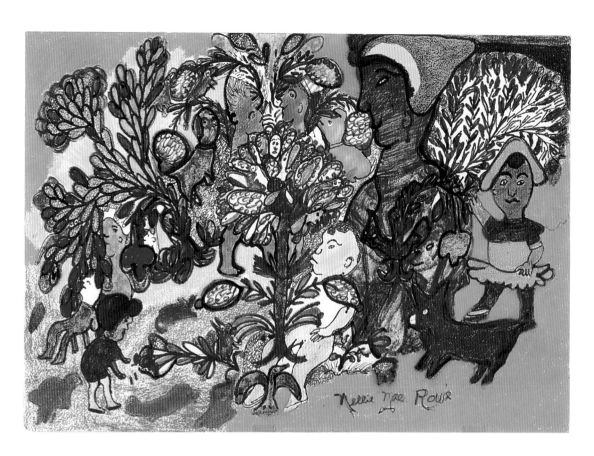

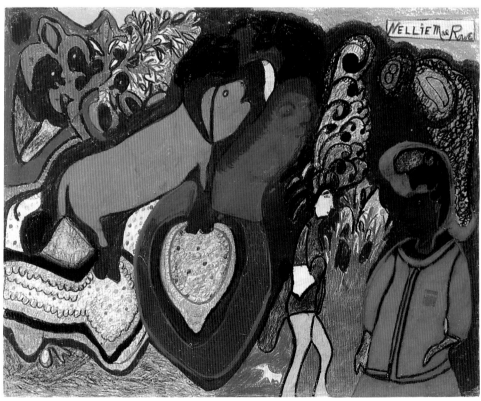

Tree of Life *1979*
Untitled (Peach Lady) *1979*

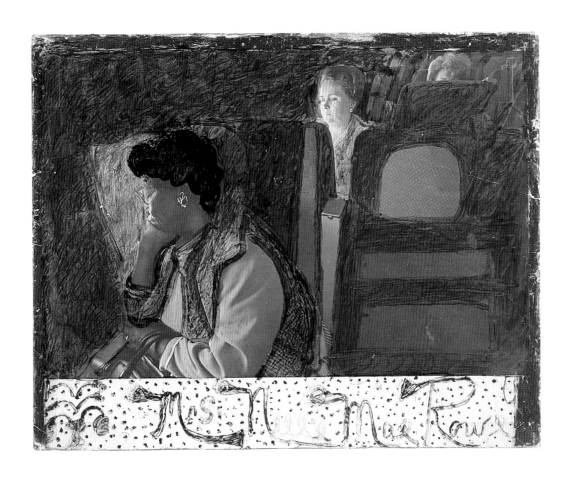

I would take nothin'
and make somethin' out of it.
Ever since I was a child,
I've been that way.

 Nellie Mae Rowe on Airplane *1979*

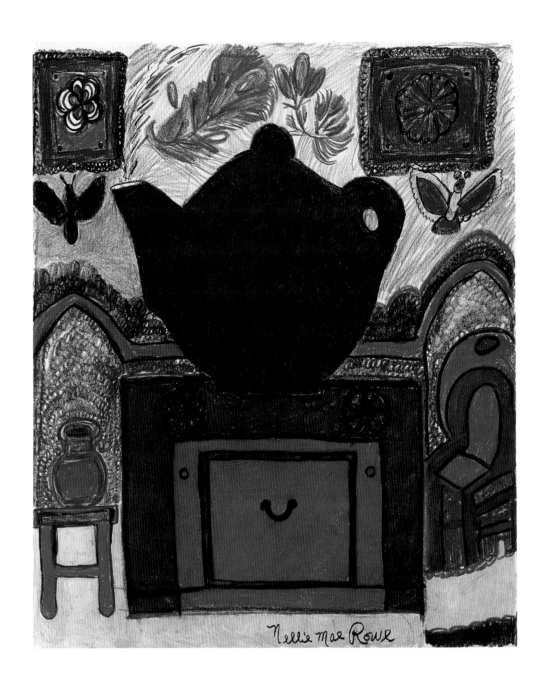

Nellie's Teapot *1979*

I sit and study what I want to draw.
If I see a man's head, a woman's head,
woman's feet, or anythin'
I start from that
I may make a start with a straight mark
and it will come to me what I want to make.

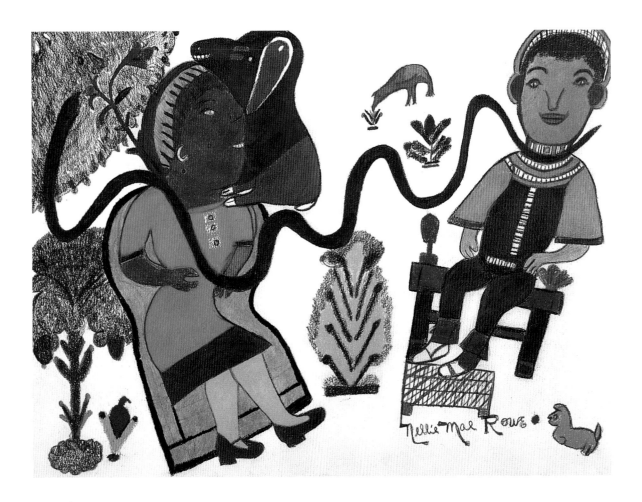

And also if I'm goin' to draw a tree,
I wouldn't know what kind it's goin' to be until I get started.
Then it may turn out to be different from what
I started it to be. I can draw roses real good.
I don't have to look at them.
I just know how roses grow, how vines and trees grow.

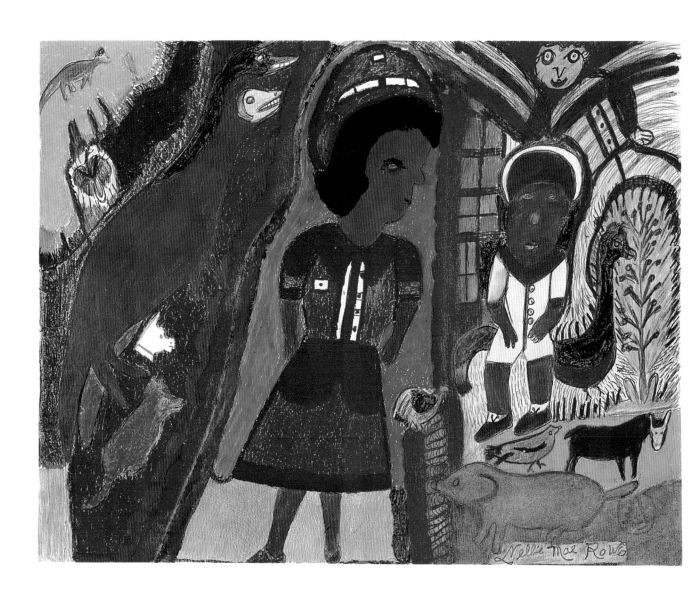

Untitled (Woman in Orange and Red) *1979*

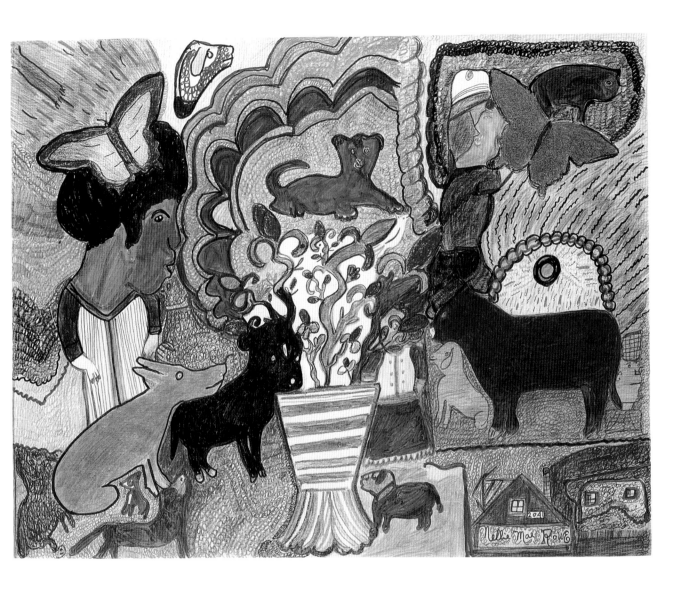

2041 Paces Ferry Road, Vinings *1979*

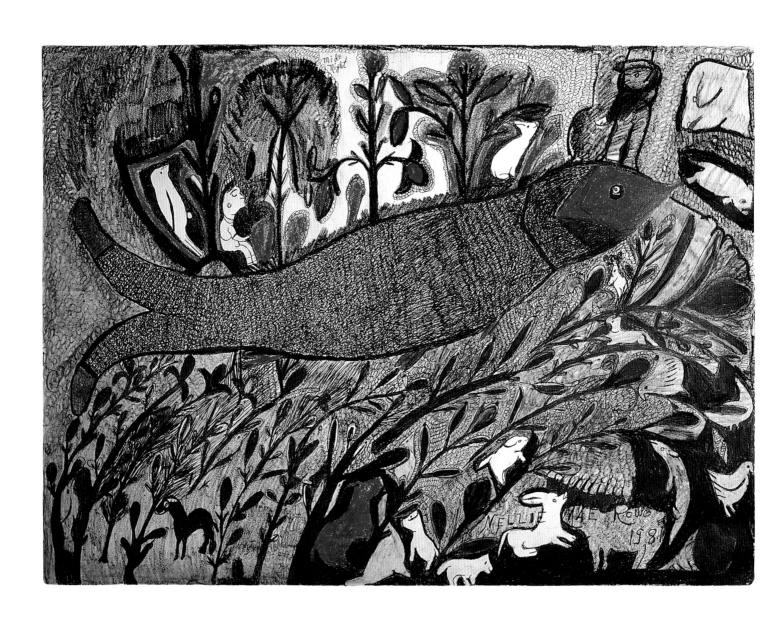

36 Mide Night *1981*

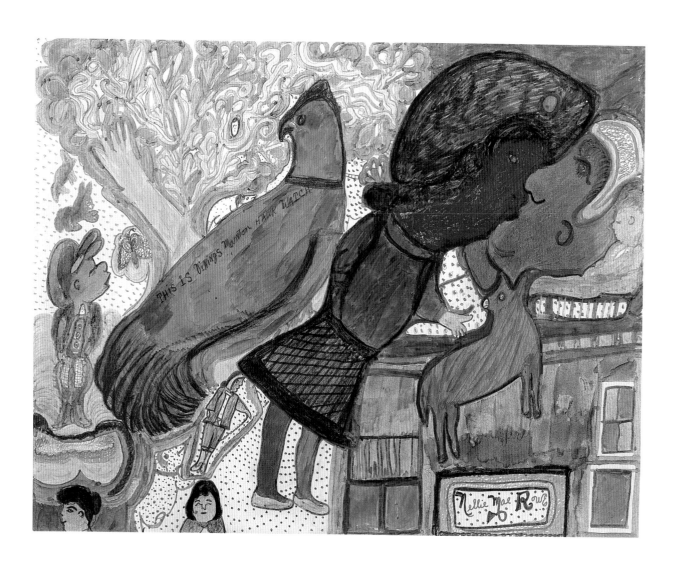

This Is Vinings Mounton Hawk Watch *1979*

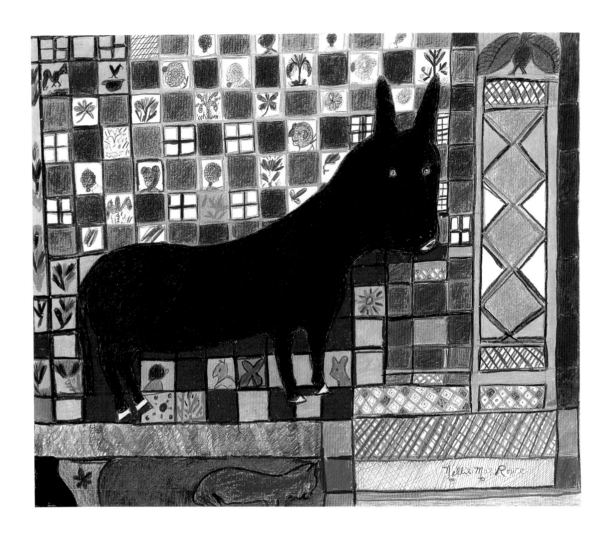

Molly *1979*

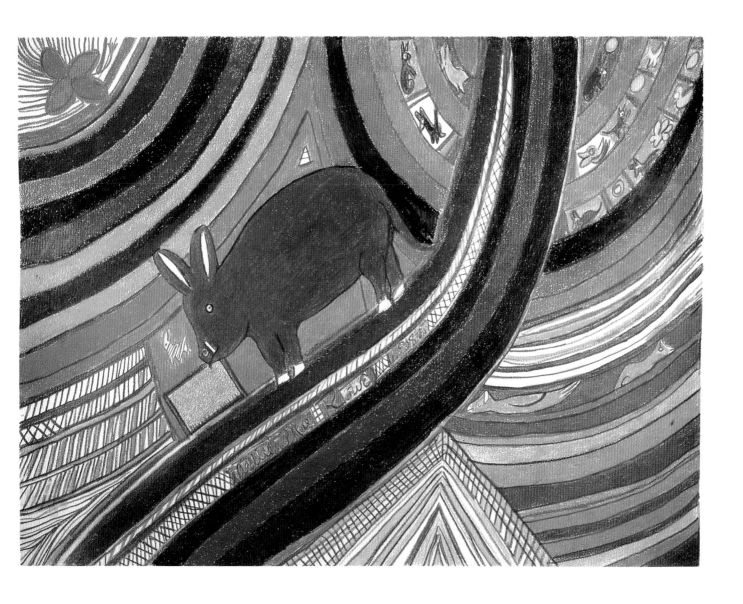

Pig on Expressway *1980*

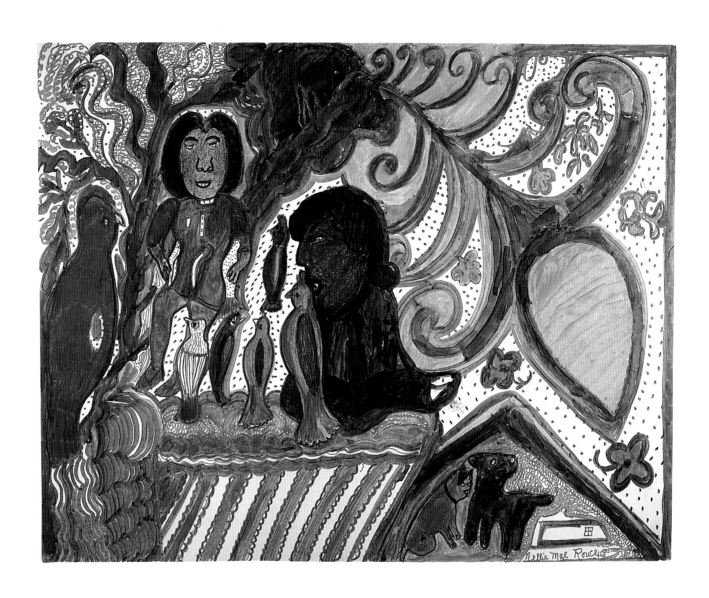

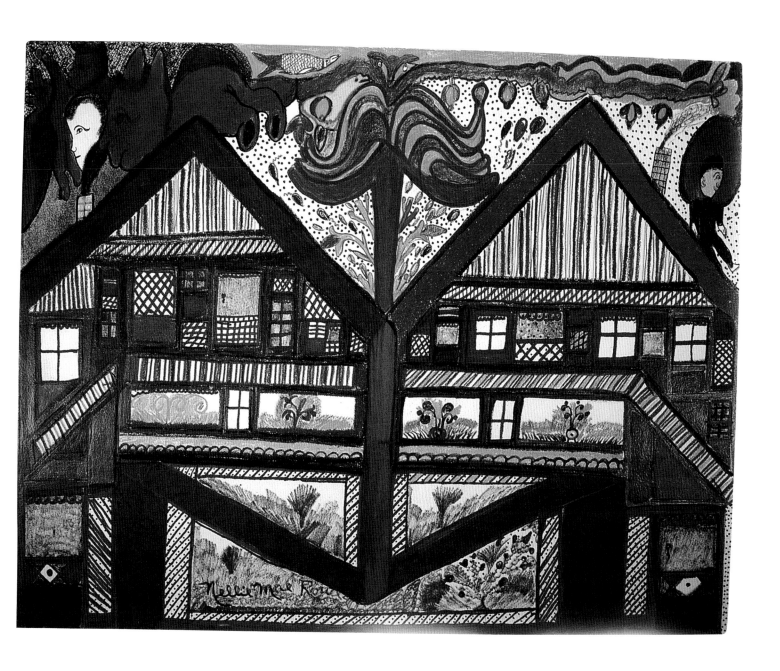

Nellie Mae and Judith's Houses *1980*

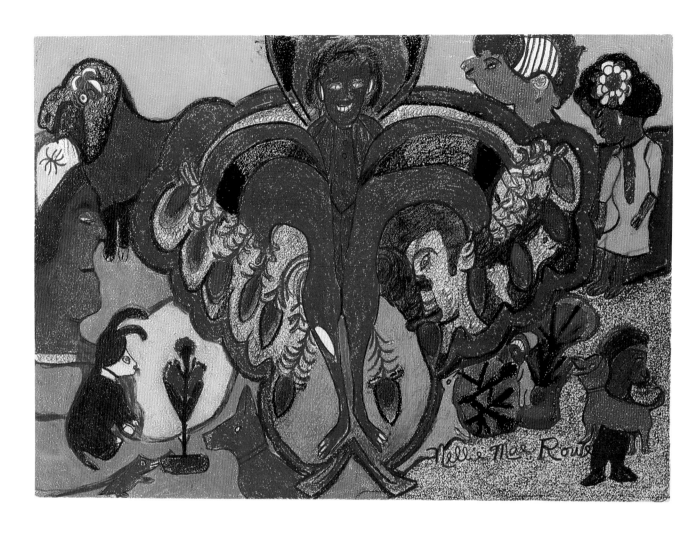

Untitled 1980

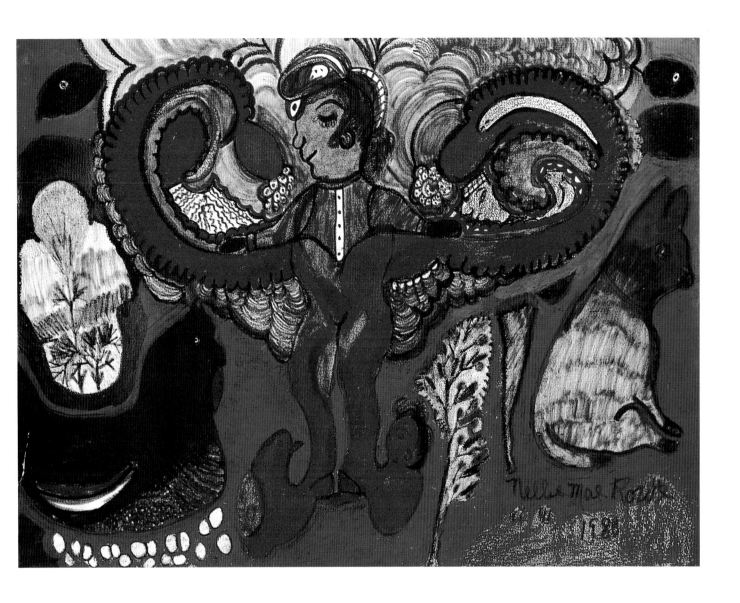

Fan Dancer *1980*

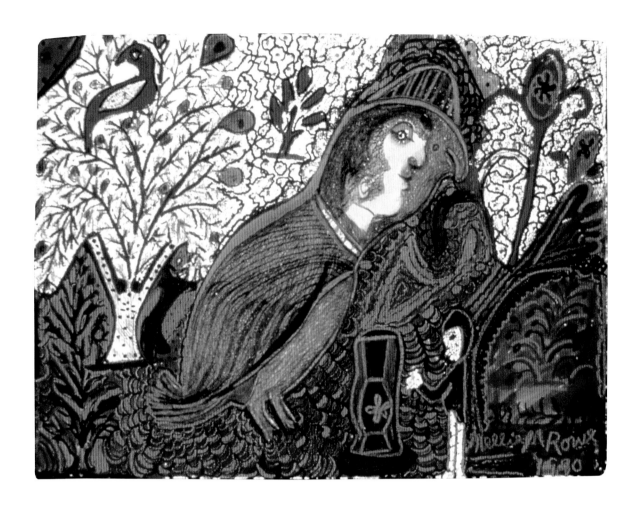

Green Parrot *1980*

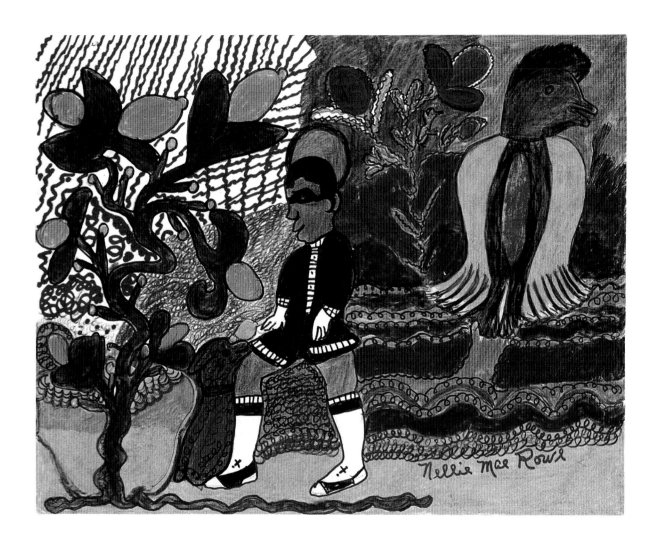

Untitled (Orange Tree/White Socks) *1980*

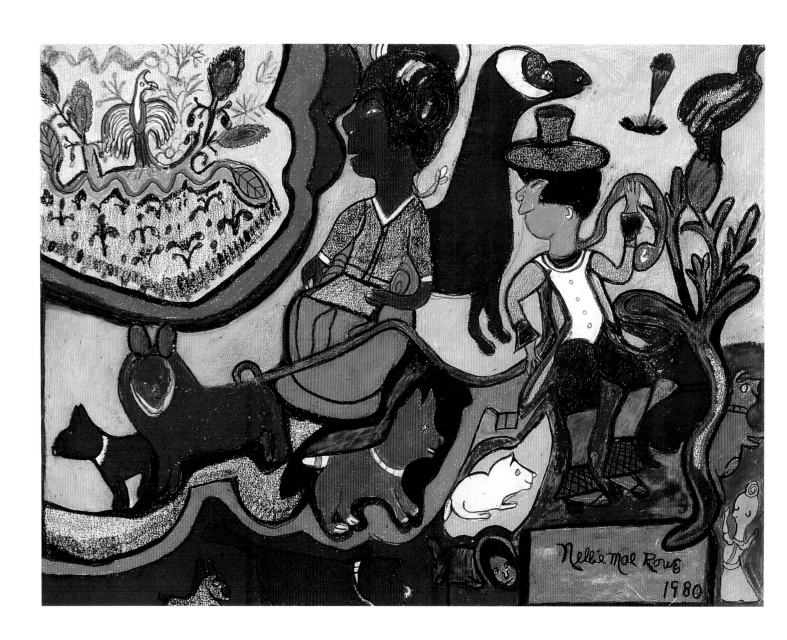

Nellie Mae and Joe Looking into Heaven *1980*

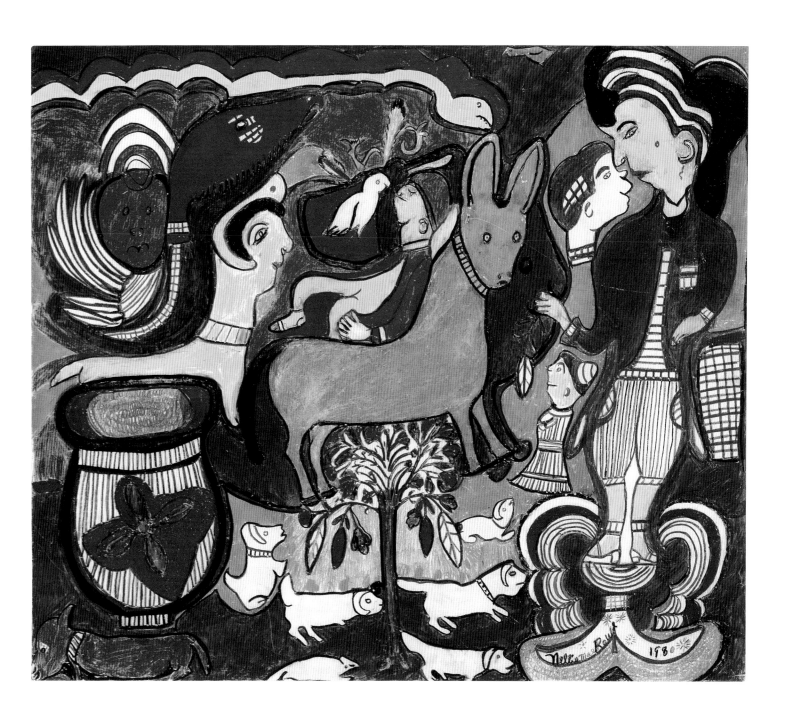

Untitled *1980*

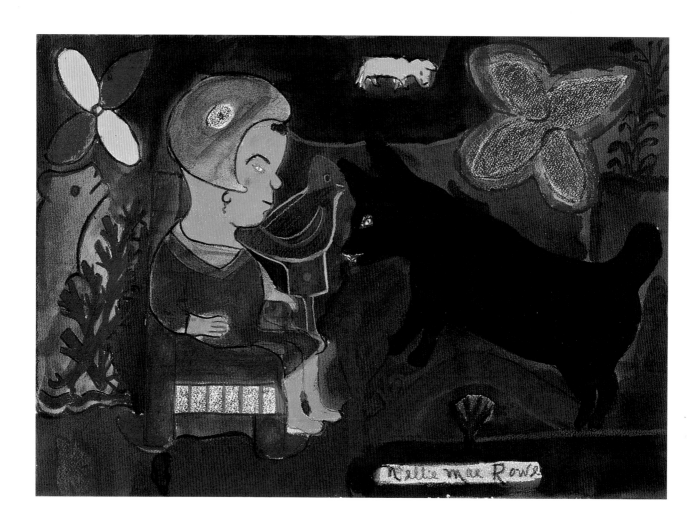

What is surprisin' and makes me feel good
is to think about people I would never have seen,
if I had not been doin' things like this
that was interestin' to them.
And it is interestin' to me to see them
while here on this earth.

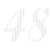 Untitled (Woman and Black Dog) *1980*

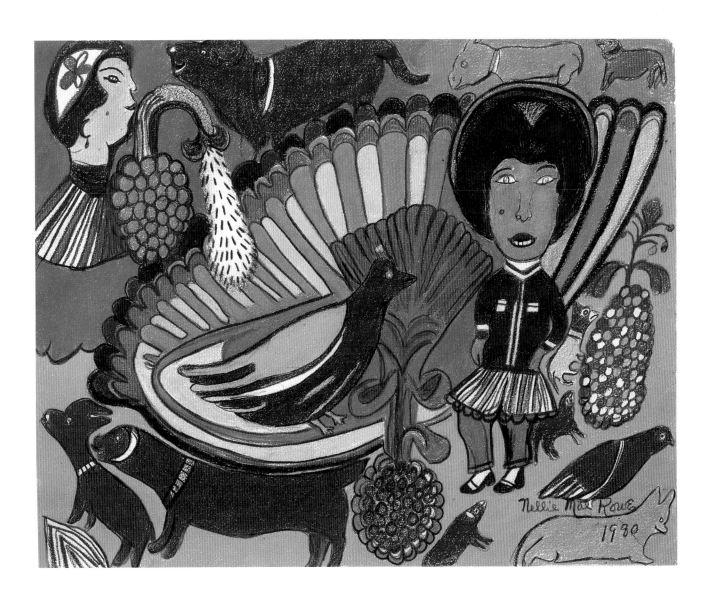

 Untitled *1980*

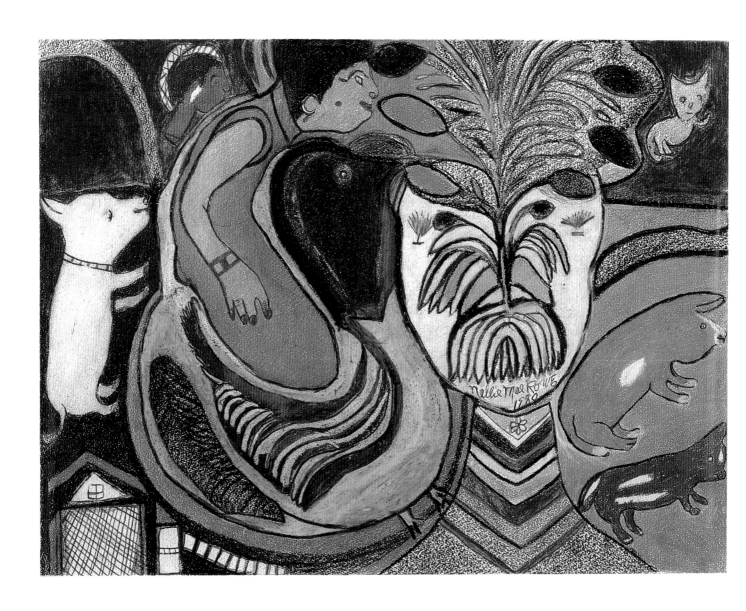

 Untitled *1980*

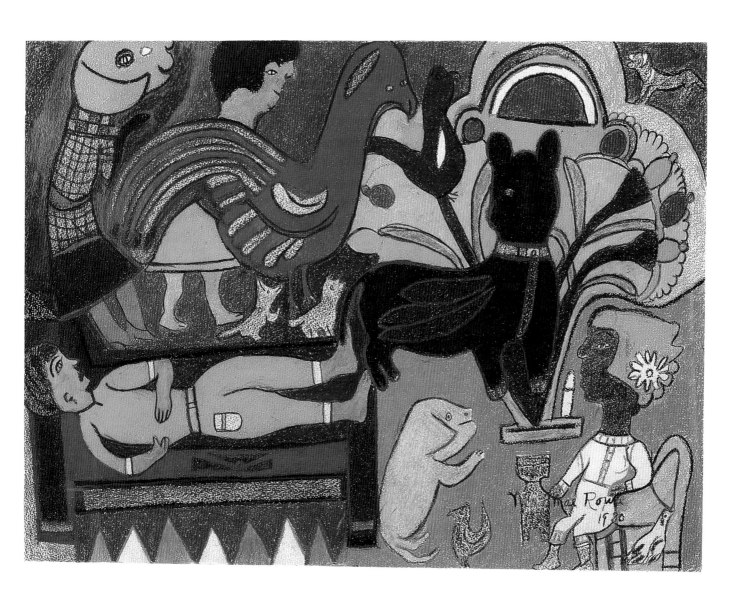

At Night Things Come to Me *1980*

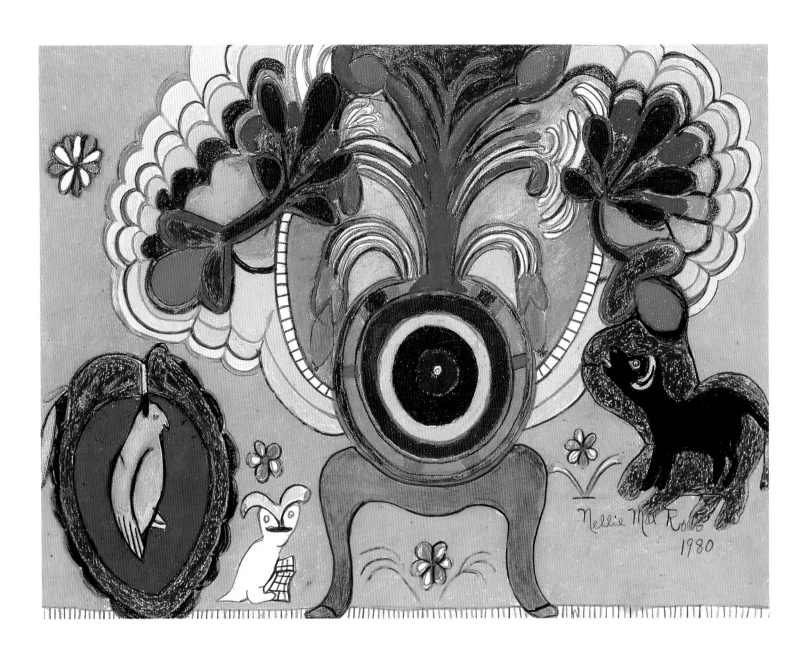

Untitled (Plant) *1980*

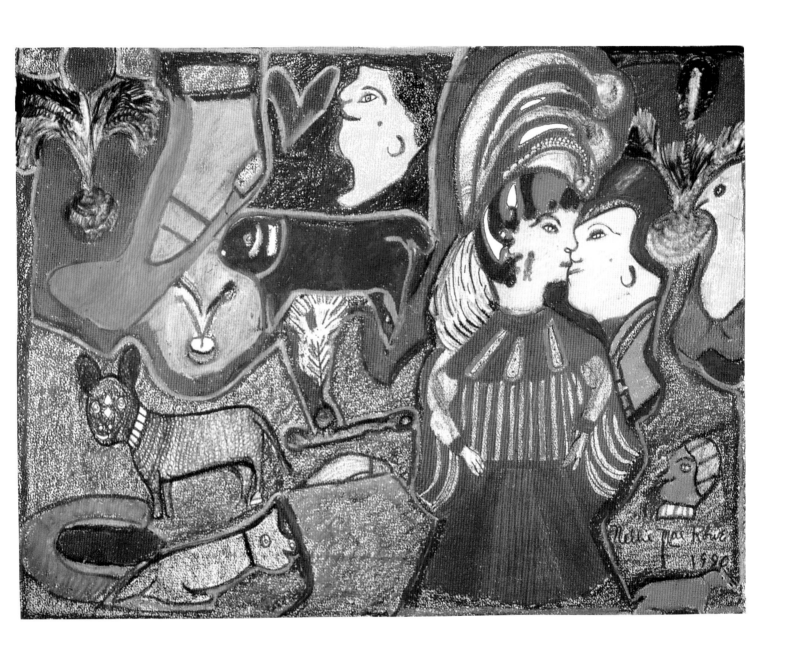

Harlem *1980*

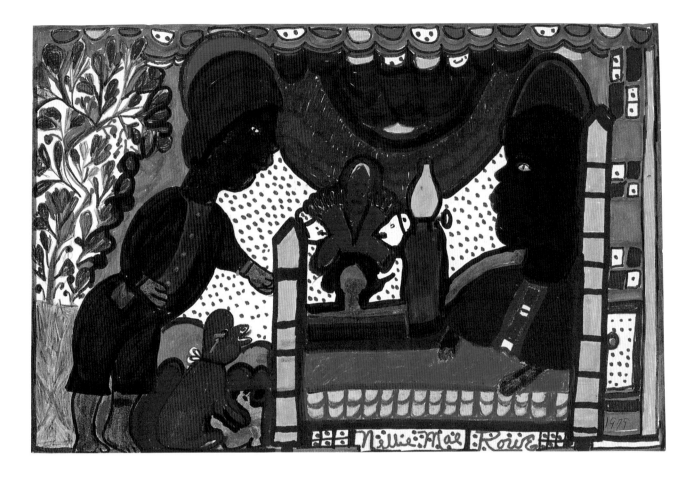

He's everythin'. I can't tell you what sort of shape He is in or what He is.

I ain't ever seen Him and nobody else has seen Him.

People go and even draw Him, make pictures of Him. They don't know

whether He is white or black, or who or what the Lord is.

Who is He? Nobody knows what He is. He stays by my side.

He's the one who gave me this hand. Everybody He gives somethin' to do.

He didn't give me no children, but this is the gift He gave me.

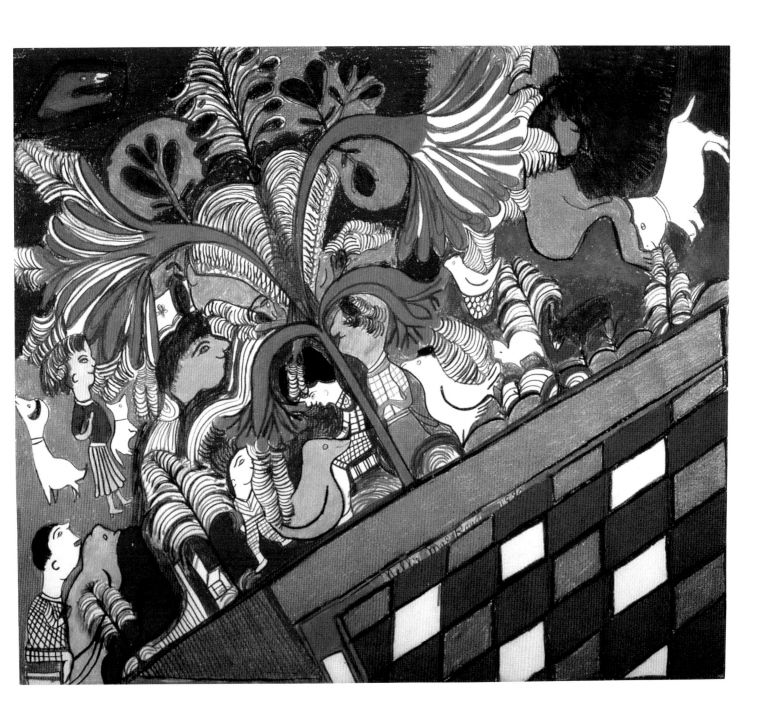

Expressway *1980*

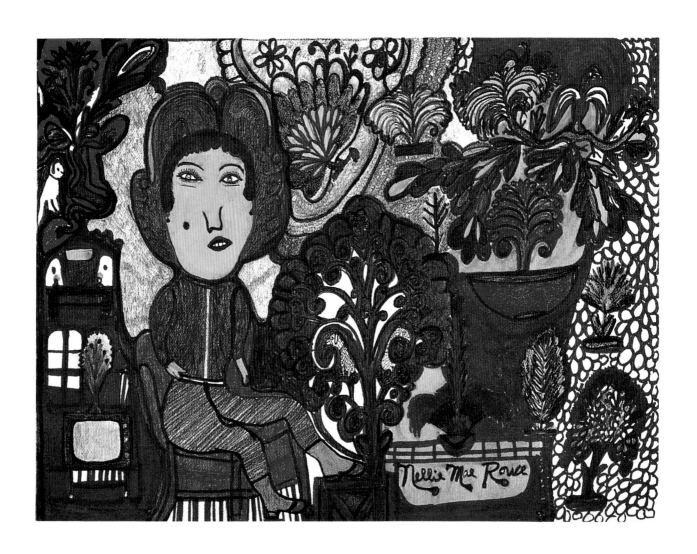

Giuliana *1979*

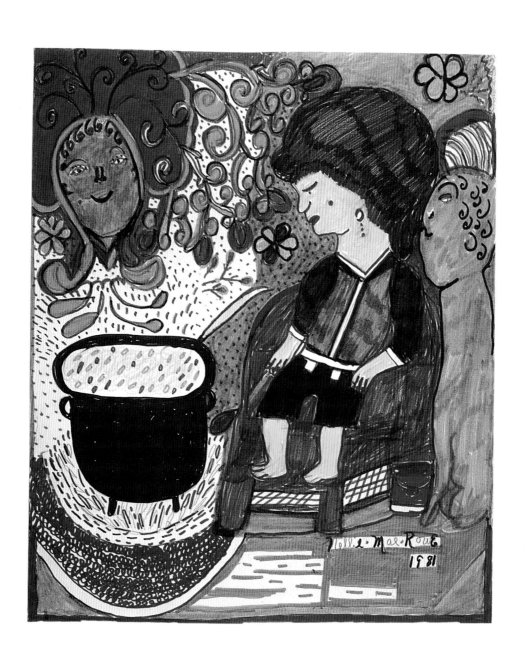

Making Soap *1981*

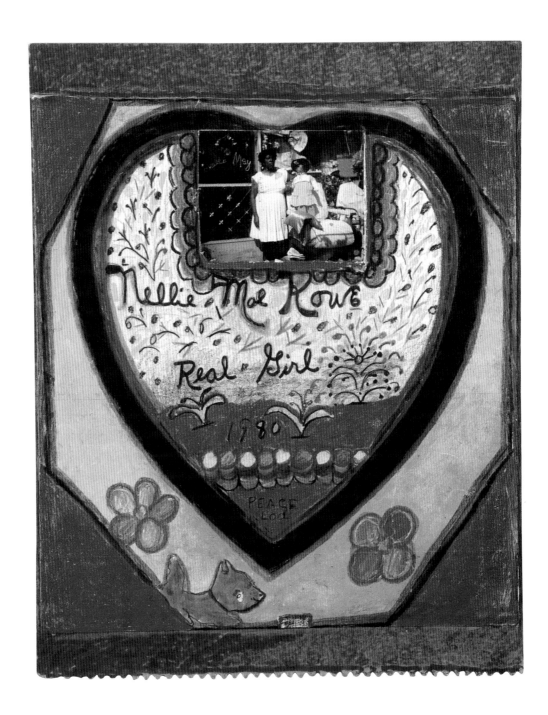

Seem like God gives everybody a talent and I guess
makin' little stuffs is mine.
And people comes from near and far
to see my little junks. Folks likes to see them
and I like to see folks.

 —Ellen Hopkins, *Georgia Life* magazine (Summer 1975)

Real Girl *1980*

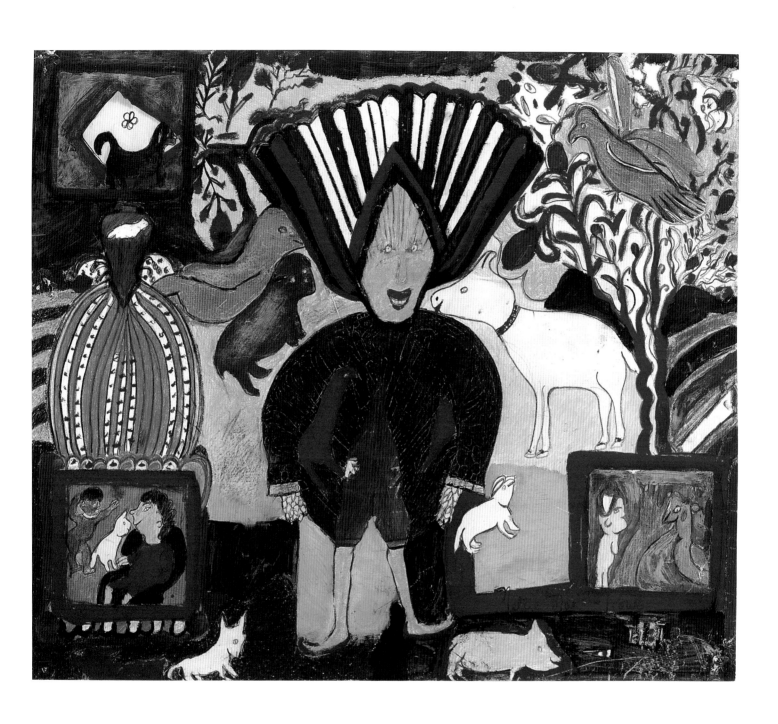

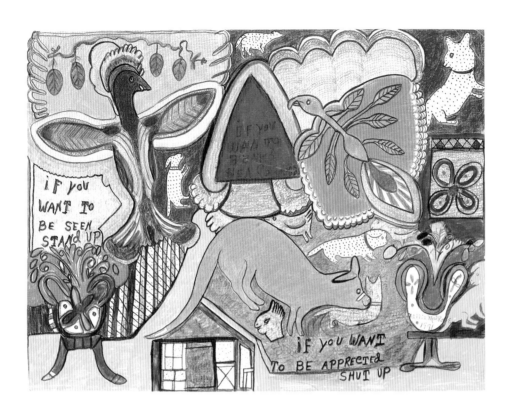

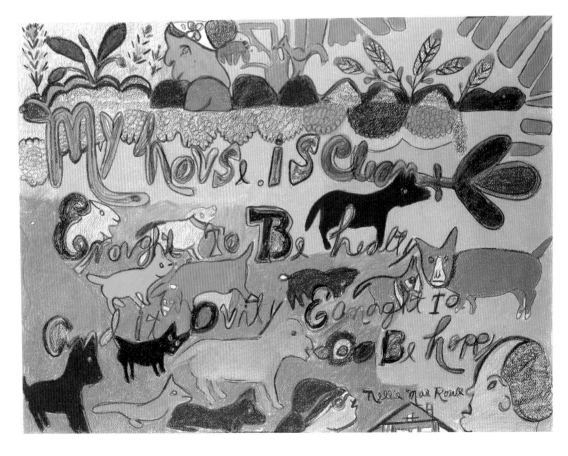

If You Want To Be Seen . . . *1981*

My House Is Clean Enought To Be Healty . . . *1981*

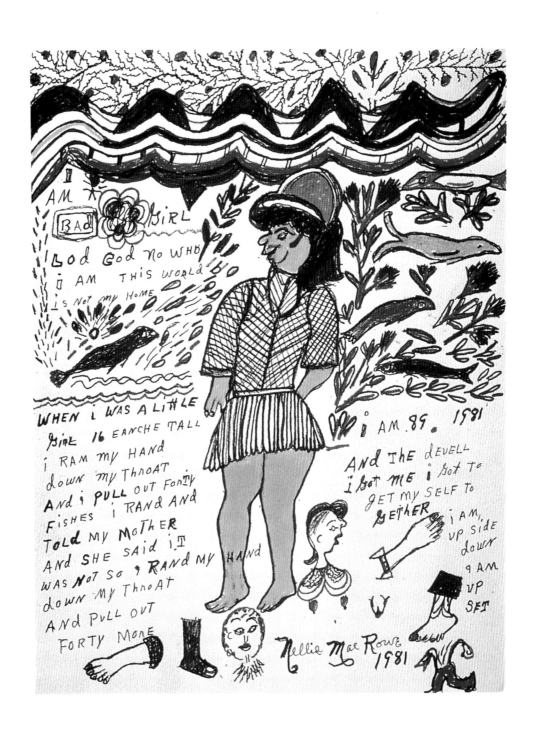

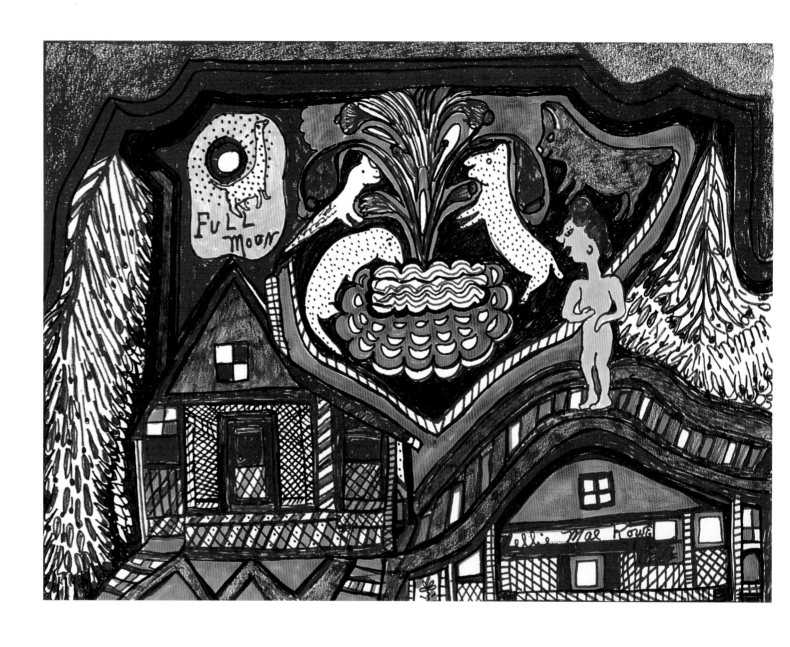

Full Moon *1981*

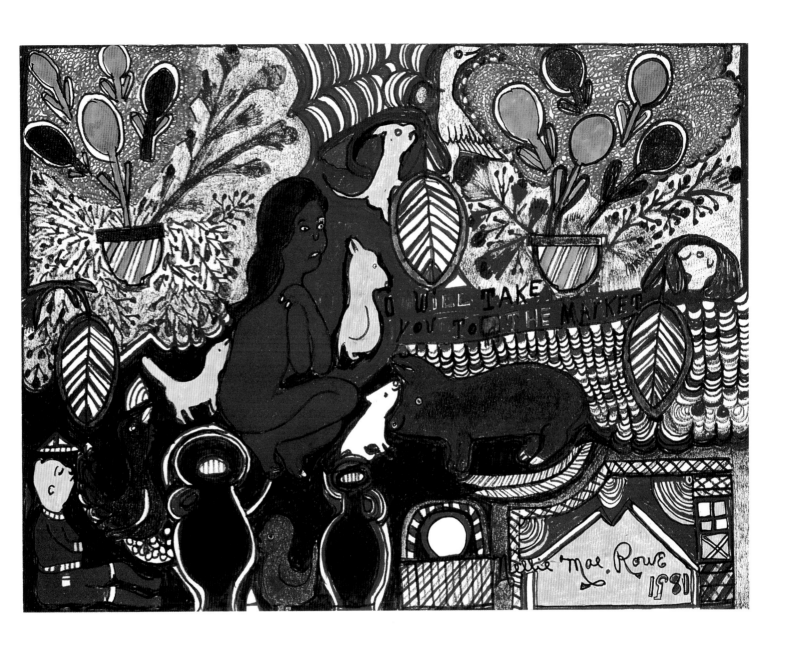

I Will Take You to the Market *1981*

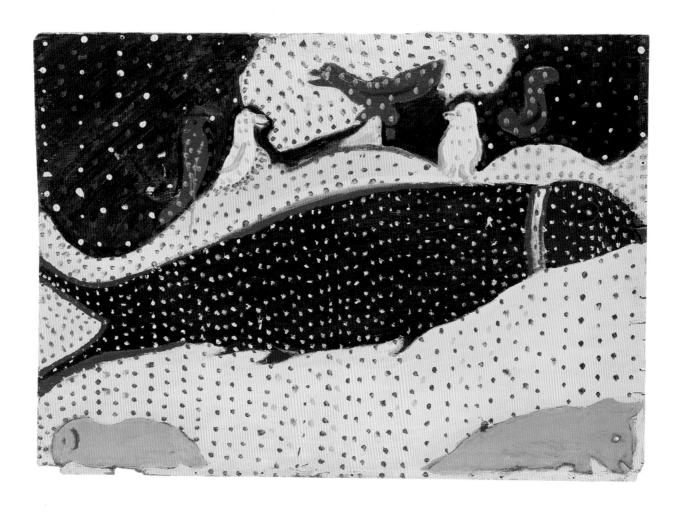

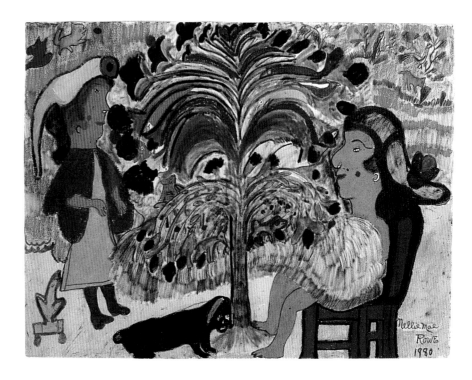

 Black Fish *1981*
Untitled (Two Women Talking) *1981*

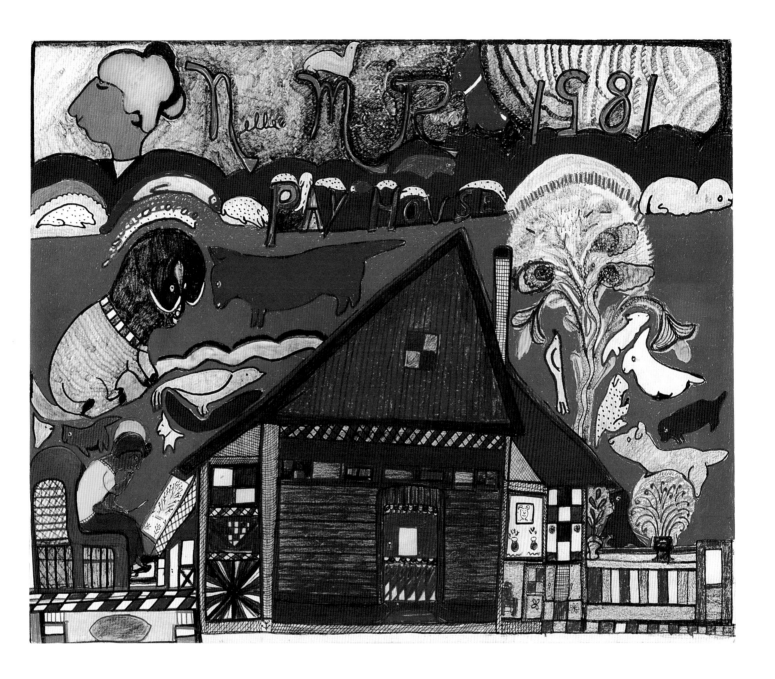

That carton hangin' on the tree,
I drew on it with lipstick but it melted.
Used to be those colors were bright. But
I like it that things keep on changin',
keeps me busy.

Payhouse [Playhouse] *1981*

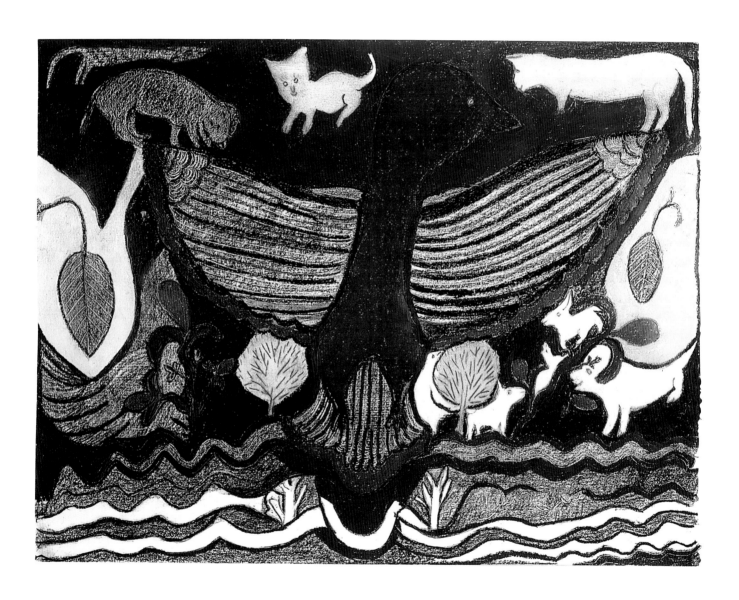

When the Eagle Flies *1981*

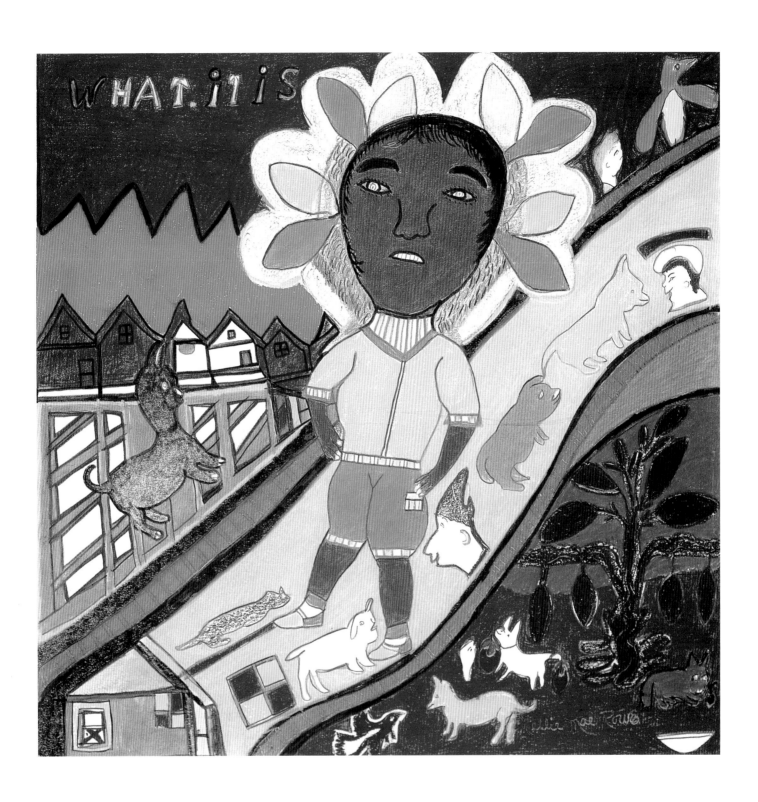

What It Is *1981*

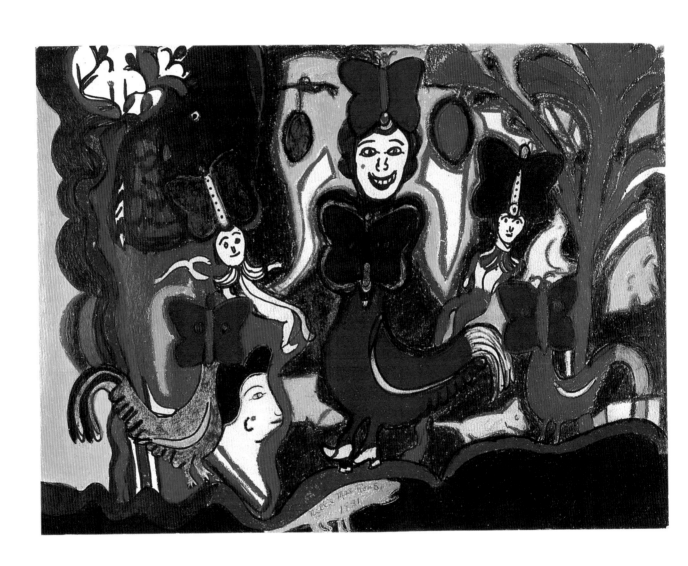

Butterfly/Bird/Woman *1981*

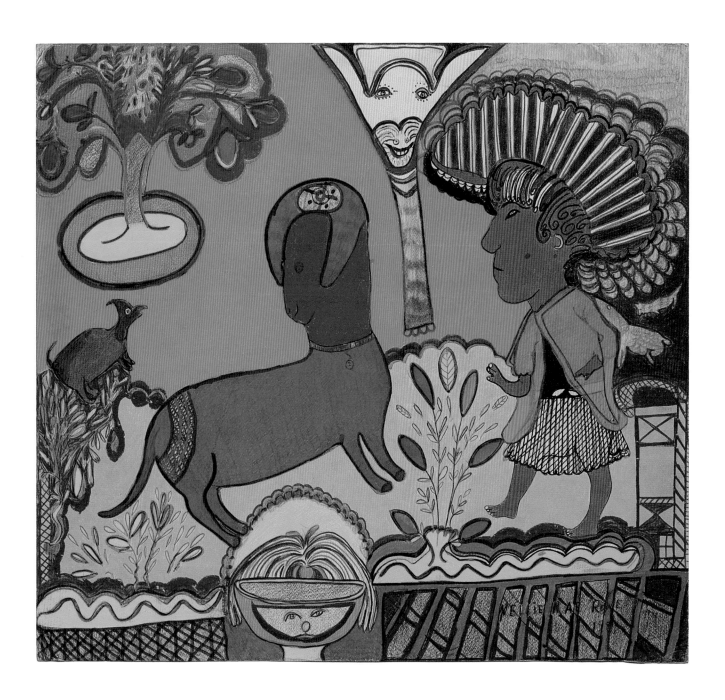

I lived a good little life and after he [Henry Rowe]
died in 1948 I said, no more foolin' around.
No more cookin', no more marryin'. . . .
I decided I kept house long enough,
I don't want to be bothered by nobody 'cept myself.

Woman Scolding Her Companion *1981*

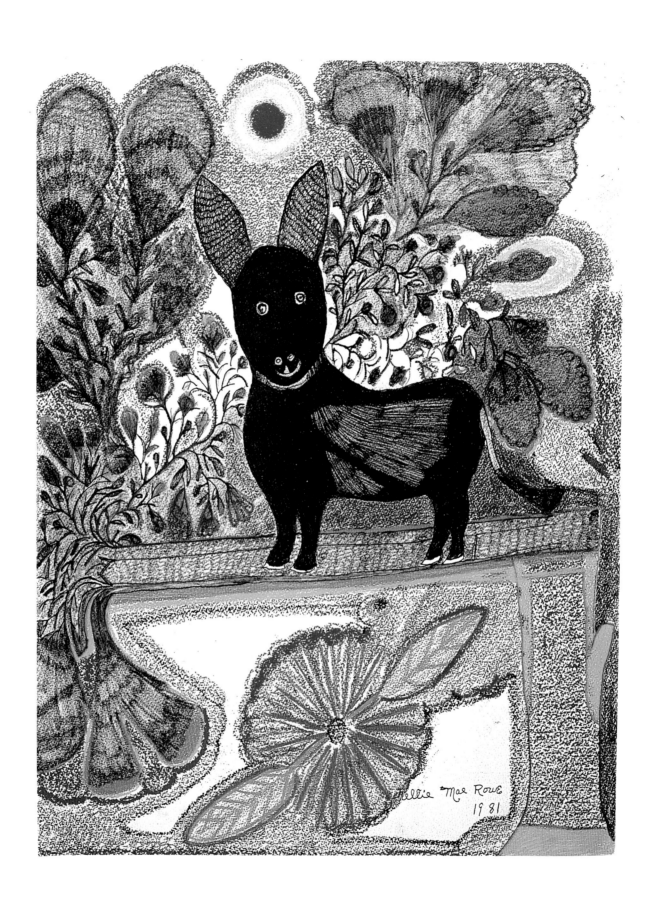

Winged Dog on Expressway *1981*

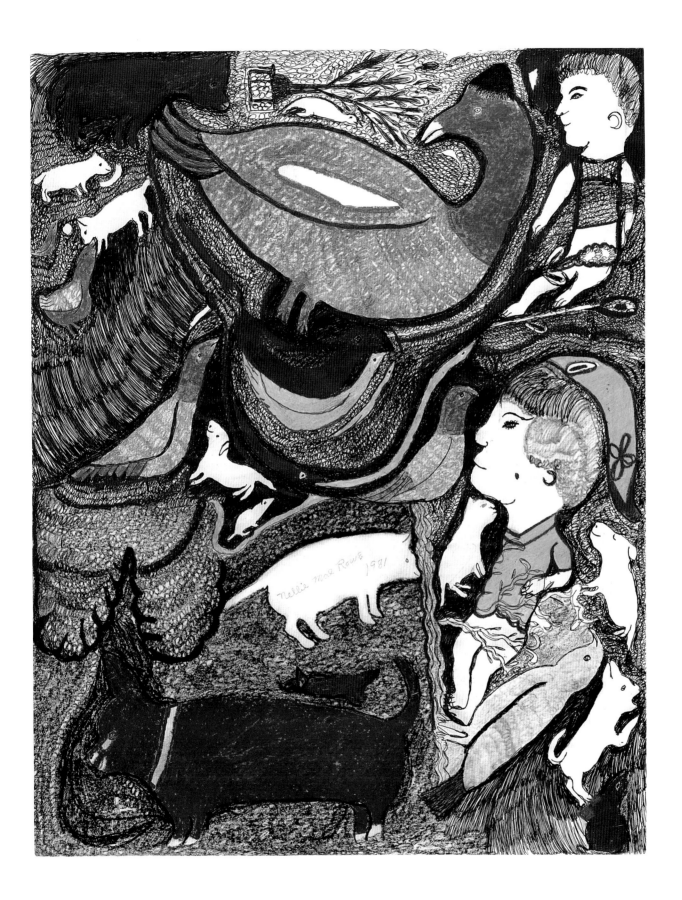

73 Untitled (Woman Talking to Animals) *1981*

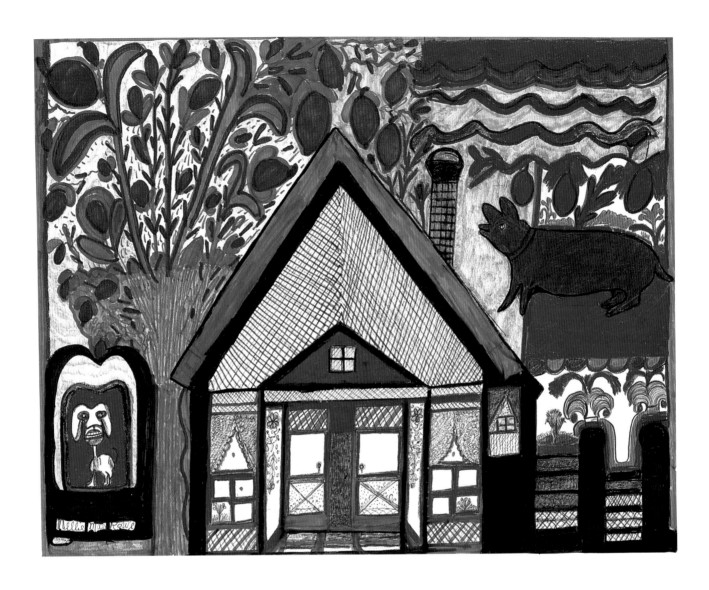

Nellie Mae Rowe's House at Night *1981*

The yard was decorated pretty.
People started comin' here takin' pictures.
It used to be people lookin' and comin',
and the traffic would be held up
from the railroad clear up to here.

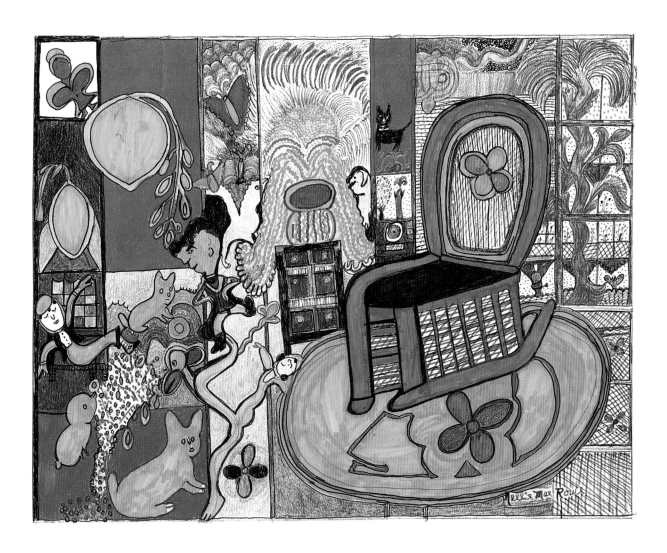

Rocking Chair *1981*

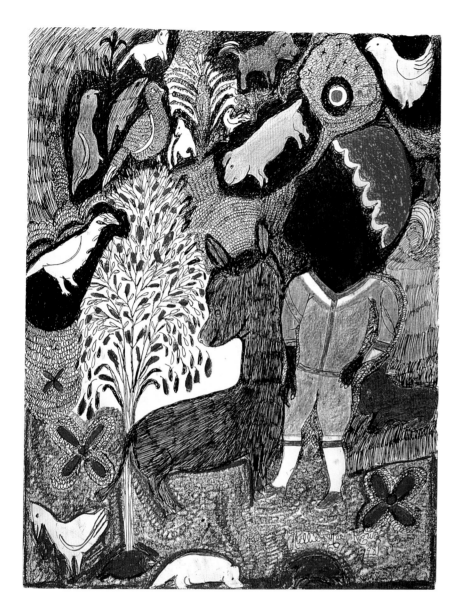

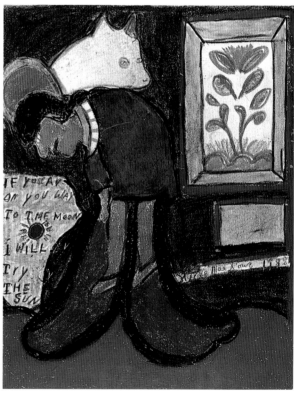

Untitled (Looking Up) *1981*
If You Ar on You Way to the Moon I Will Try the Sun *1982*

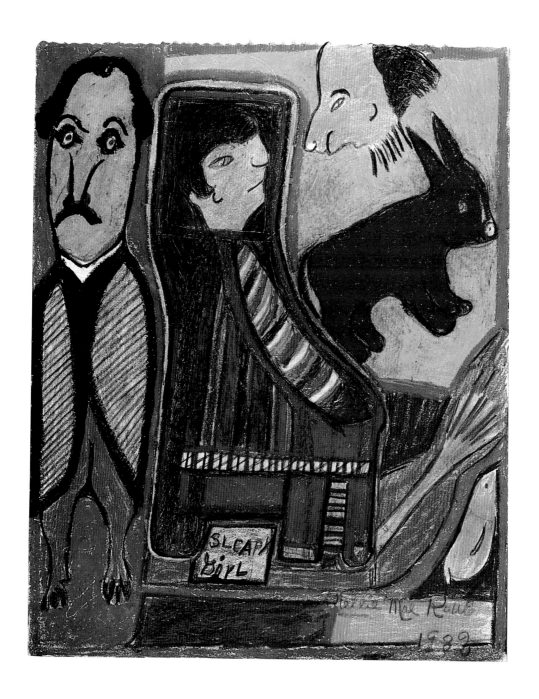

I just draw the way I see things.
I see people crippled and I may draw them
to ask the Lord to help 'em,
help 'em on through.
Nothin' I draw to make fun of. I draw things I see
of people's condition and ask the Lord
to help them.

Sleapy Girl 1982

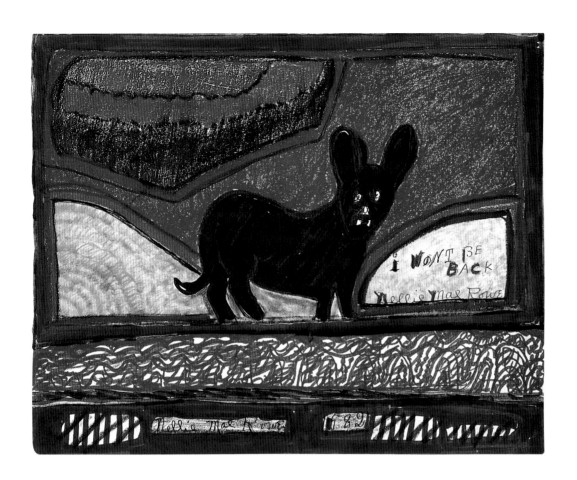

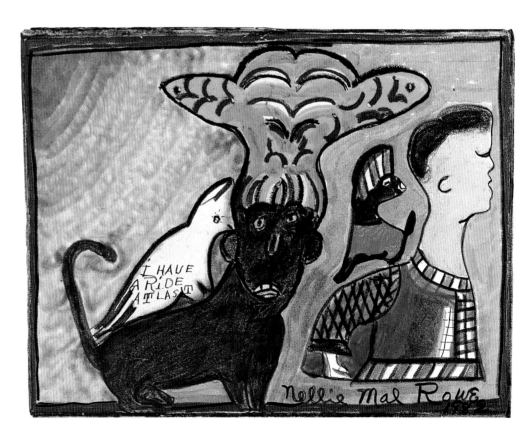

I Won't Be Back *1982*

I Have a Ride at Last *1982*

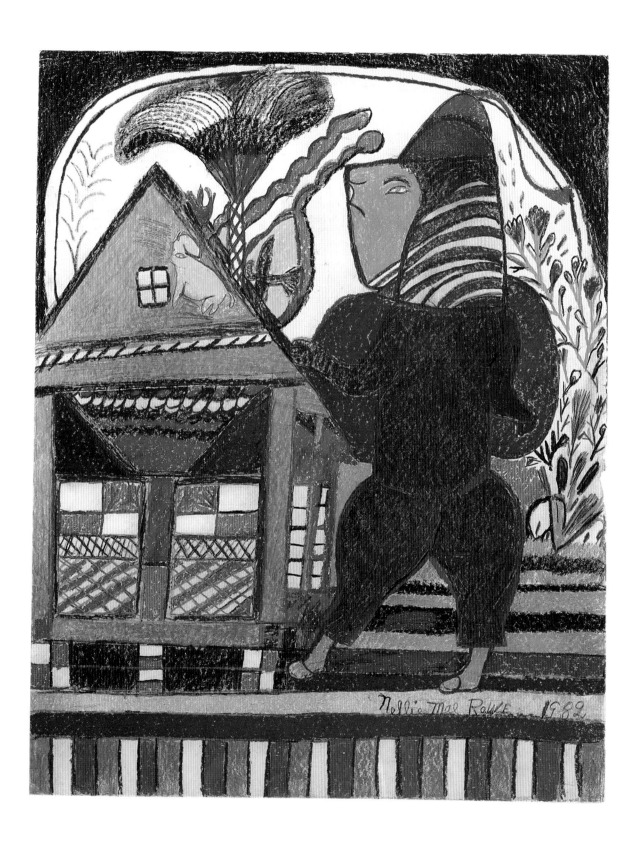

Untitled (Dog) *1982*

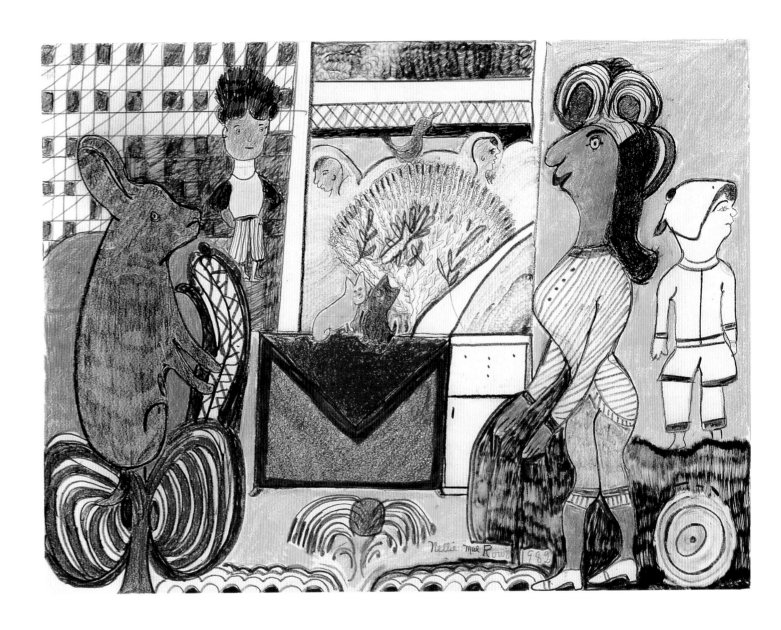

Going Home *1982*

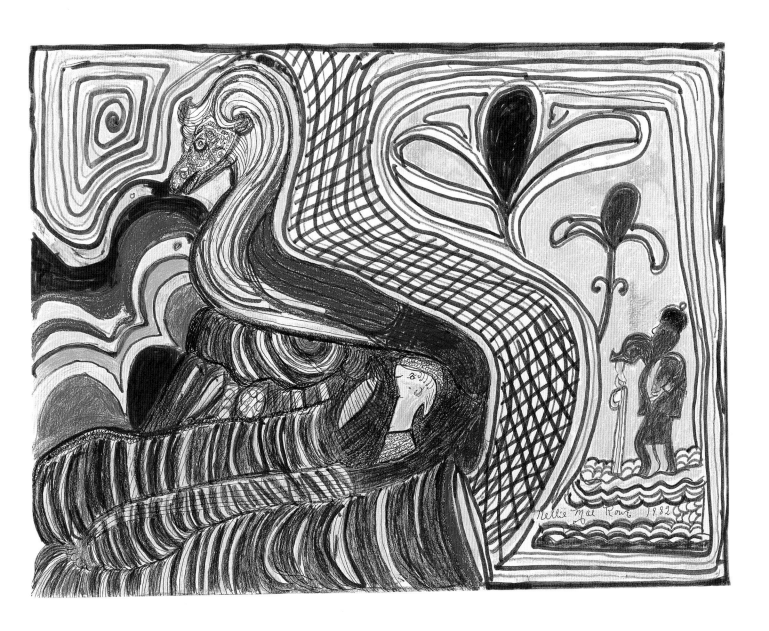

Look Back in Wonder How I Got Over *1982*

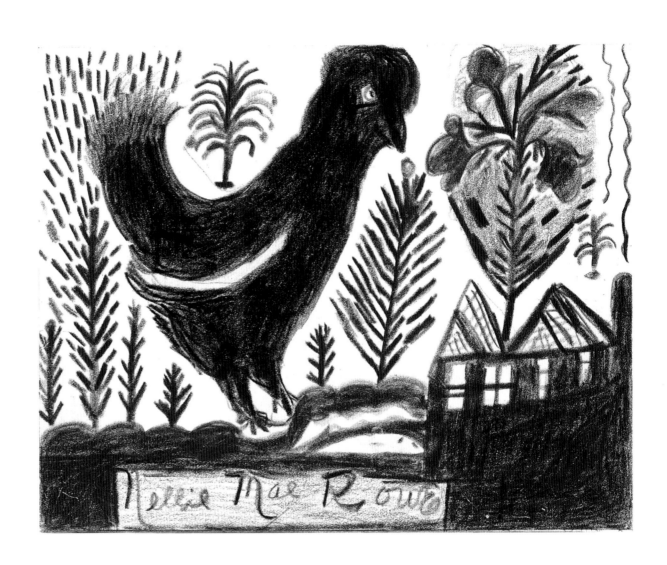

Black Rooster *1982*

EXHIBITION CHECKLIST

1. *Green Rooster*
c. 1972
Watercolor, pencil, and crayon
on paper
16 × 24½"
Collection of Washington and Judy Falk

2. *Four Faces*
c. 1972
Crayon on pressed-paper tray
8¾ × 5¾ × ¾" each
Museum of American Folk Art, gift of
Judith Alexander, 1997.1.11

3. *White Horse*
1964
Chalk, crayon, and pencil on cardboard
9½ × 14"
Private collection

4. *Something That Ain't Been Born Yet*
1978
Crayon and pencil on ledger paper
13½ × 8¼"
Private collection

5. *Please Let Me Be*
Dated 1947 [1974?]
Pencil, acrylic, and felt-tip pen on
calendar page, collaged on matboard
9½ × 7¼"
Private collection

6. *Thunder Bolt Pattson [Patterson] Rassler*
c. 1975
Crayon and pencil on paper
11 × 8½"
Private collection

7. *Woman (Chewing Gum Sculpture)* [left]
c. 1972
Chewing gum with marbles, hair,
plastic flowers, and plastic animal
on wooden base
7½ × 5½ × 4"
Collection of Linda Connelly

8. *Head (Chewing Gum Sculpture)* [right]
c. 1981
Chewing gum with paint and beads
on wooden base
4¾ × 2½ × 3" (base 4½ × 4½")
Collection of Joe Brown Sr.

9. *Handsewn Doll* [top]
c. 1981
Synthetic fabric body with wig, red
hat, eyeglasses, and mechanical watch
37½ × 17 × 8½"
Private collection

10. *Handsewn Doll* [right]
c. 1974
Cotton, paint, eyeglasses, and
acrylic wig
24 × 14 × 6"
Museum of American Folk Art,
gift of Herbert Waide Hemphill Jr.,
1996.5.3

11. *Handsewn Doll* [bottom]
c. 1980
Nylon fabric, royal blue T-shirt, wig,
and beaded Indian necklace
21 × 8 × 8"
Collection of Judith M. Anderson

12. *Handsewn Doll* [left]
c. 1980
Red velvet, short petticoat, and wig
25 × 20 × 6½"
Private collection

13. *Untitled (Girl in Blue)*
1978
Felt-tip pen on paper
14 × 11"
Collection of Dr. Siri von Reis

14. *Twins Boys*
1978
Felt-tip pen on paper
18 × 24"
Collection of Chuck and Jan Rosenak

15. *Nellie Mae Rowe*
1978
Felt-tip pen and ink on paper
10 × 13½"
Collection of Judith A. Augustine

16. *I Will Sea You at the Rafter Some Sweat Day*
1978
Colored pencil on paper
19 × 24"
Collection of Beverly and Jerome Siegel

17. *Humpy [Humphrey]*
1978
Crayon, pencil, and felt-tip pen
on paper
19 × 24"
Private collection

18. *Picking Cotton*
1978
Colored pencil, pencil, and felt-tip
pen on paper
11 × 14"
London Family Collection

19. *Alligator Man*
1978
Felt-tip pen and ballpoint pen on paper
24 × 19"
London Family Collection

20. *Untitled*
1978
Colored pencil on paper
19 × 24"
Collection of Joshua Feldstein

21. *Peace*
1978
Crayon and pen on paper
17 × 14"
Private collection

22. *Peach*
1979
Crayon and ballpoint pen on paper
17 × 14"
Collection of Dorothea and Leo Rabkin

23. *Summer Time*
1979
Crayon, pencil, pen, and colored
pencil on paper
24½ × 19½"
Collection of Edward V. Blanchard
and M. Anne Hill

24. *Joe and Eva*
1979
Colored pencil and pencil on paper
15 × 19½"
Collection of Eleanor Shropshire

25. *Nellie Mae Making It to Church Barefoot*
1978
Crayon and pencil on paper
19¼ × 24"
Private collection

26. *Cow Jump over the Mone*
1978
Colored pencil, pencil, and crayon
on paper
19½ × 25¼"
Museum of American Folk Art, gift of
Judith Alexander, 1997.10.1

27. *Haints*
1978
Pelikan ink on paper
15 × 20"
Collection of Cecil Alexander

28. *Creation*
1979
Felt-tip pen on paper
19 × 24"
Collection of Sally and Paul Hawkins

29. *Tree of Life*
1979
Crayon, felt-tip pen, and watercolor
on paper
20¼ × 26½"
Collection of Mr. and Mrs.
Richard S. Lambert

30. *Untitled (Peach Lady)*
1979
Crayon on paper
19 × 24"
Collection of Ruth West Wells

31. *Nellie Mae Rowe on Airplane*
1979
Felt-tip pen on photograph taken by
Lucinda Bunnen
7⅞ × 9⅞"
Private collection

32. *Nellie's Teapot*
1979
Crayon and colored pencil on paper
17 × 14"
Collection of Harvie and Chuck Abney,
promised gift to the High Museum of
Art, Atlanta

33. *Conversation*
1979
Crayon and pencil on paper
18¾ × 24"
Private collection

34. *Untitled (Woman in Orange and Red)*
1979
Crayon and pencil on paper
19 × 24"
High Museum of Art, Atlanta,
T. Marshall Hahn Jr. Collection,
1997.108

35. *2041 Paces Ferry Road, Vinings*
1979
Pencil, felt-tip pen, and colored
pencil on paper
19¼ × 24½"
Collection of Judith M. Anderson

36. *Mide Night*
1981
Ballpoint pen and crayon on paper
22 × 30"
Private collection

37. *This Is Vinings Mounton Hawk Watch*
1979
Felt-tip pen and crayon on paper
19¼ × 24½"
Collection of Anthony Hudgins and
Dr. Meg Scarlett

38. *Molly*
1979
Crayon, ink, and pencil on paper
17¾ × 21¾"
Collection of Jeffrey Mindlin

39. *Pig on Expressway*
1980
Crayon on paper
18 × 24"
Private collection

40. *Untitled*
1979
Crayon and felt-tip pen on paper
18⅞ × 24"
Collection of Joe Brown Sr.

41. *Nellie Mae and Judith's Houses*
1980
Crayon, felt-tip pen, pencil, and
gouache on paper
19 × 24"
Private collection

42. *Untitled*
1980
Crayon and pencil on paper
14 × 20"
Private collection

43. *Fan Dancer*
1980
Crayon, colored pencil, and pencil
on paper
18 × 24"
Collection of Harvie and Chuck Abney

44. *Green Parrot*
1980
Gouache, ink, crayon, and pencil
on paper
18 × 23⅞"
The Studio Museum in Harlem,
New York, gift of Judith Alexander,
86.13

45. *Untitled (Orange Tree/White Socks)*
1980
Crayon, pencil, and felt-tip pen
on paper
10¾ × 13¾"
London Family Collection

46. *Nellie Mae and Joe Looking into Heaven*
1980
Crayon and pencil on paper
18 × 24"
Private collection

47. *Untitled*
1980
Crayon and pencil on paper
25 × 30"
Private collection

48. *Untitled (Woman and Black Dog)*
1980
Pelikan ink and crayon on paper
14¼ × 20¼"
Private collection

49. *Untitled*
1980
Crayon and pencil on paper
16½ × 20½"
Private collection

50. *Untitled*
1980
Crayon and pencil on paper
18½ × 24½"
Private collection

51. *At Night Things Come to Me*
1980
Crayon and pencil on paper
18½ × 24½"
Private collection

52. *Untitled (Plant)*
1980
Crayon on paper
18 × 24"
Collection of Joshua Feldstein

53. *Harlem*
1980
Crayon and ballpoint pen on paper
18 × 24"
Collection of Jim and Sylvia Kortan

54. *Visitation*
1981
Pastel and felt-tip pen on paper
11¾ × 17¾"
Private collection

55. *Expressway*
1980
Pencil, pen, and crayon on paper
25 × 30"
Collection of Steven and Catherine Fox

56. *Giuliana*
1979
Felt-tip pen on paper
18 × 24"
Collection of Giuliana Kaufman

57. *Making Soap*
1981
Felt-tip pen, pencil, and crayon
on paper
16¾ × 14"
Private collection

58. *Real Girl*
1980
Color photograph, crayon, felt-tip
pen, and pencil on cardboard
14 × 11"
Private collection

59. *Atlanta's Missing Children*
1981
Collage, crayon, gouache, and pen
on paper
28 × 30"
Private collection

60. *If You Want To Be Seen . . .*
1981
Felt-tip pen, crayon, pencil, and
colored pencil on paper
18¼ × 24"
Private collection

61. *My House Is Clean Enought To Be Healty . . .*
1981
Crayon, pencil, and colored pencil
on paper
25¼ × 31½"
Collection of Didi and David Barrett

62. *Bad Girl*
1981
Crayon, felt-tip pen, and ballpoint
pen on paper
16 × 12"
Private collection

63. *Full Moon*
1981
Felt-tip pen and crayon on paper
15 × 20½"
Collection of Dr. and Mrs.
S. Robert Lathan

64. *I Will Take You to the Market*
1981
Felt-tip pen and crayon on paper
15 × 20"
Private collection

65. *Black Fish*
1981
Acrylic on wood
26½ × 37"
Collection of Gary Davenport
in honor of Robert Bishop

66. *Untitled (Two Women Talking)*
1981
Crayon, gouache, felt-tip pen,
and pencil on paper
18 × 24"
Private collection

67. *Payhouse [Playhouse]*
1981
Crayon, felt-tip pen, and pencil
on cardboard
23½ × 30½"
Private collection

68. *When the Eagle Flies*
1981
Crayon, pencil, felt-tip pen, and
colored pencil on paper
18½ × 24"
Collection of Joshua Feldstein

69. *What It Is*
1981
Crayon, pencil, and colored pencil
on paper
22¼ × 22¼"
Private collection

70. *Butterfly/Bird/Woman*
1981
Crayon, pastel, and pen on paper
15 × 19¾"
Private collection

71. *Woman Scolding Her Companion*
1981
Crayon, felt-tip pen, pencil, and
colored pencil on cardboard
29 × 31¾"
The William S. Arnett Collection

72. *Winged Dog on Expressway*
1981
Crayon, colored pencil, felt-tip
pen, and pencil on paper
24½ × 18½"
Private collection

73. *Untitled (Woman Talking to Animals)*
1981
Pen, ink, and crayon on paper
24 × 19"
The William S. Arnett Collection

74. *Nellie Mae Rowe's House at Night*
1981
Felt-tip pen and crayon on paper
18¾ × 24"
The William S. Arnett Collection

75. *Rocking Chair*
1981
Felt-tip pen and pencil on paper
18 × 23"
The William S. Arnett Collection

76. *Untitled (Looking Up)*
1981
Colored pencil, crayon, and pen
on paper
24 × 18"
Collection of John and
Margaret Robson

77. *If You Ar on You Way to the Moon
I Will Try the Sun*
1982
Crayon, pencil, and colored pencil
on paper
10 × 8"
Museum of American Folk Art,
gift of Judith Alexander, 1997.1.7

78. *Sleepy Girl*
1982
Crayon and pencil on paper
14 × 11"
Private collection

79. *I Won't Be Back*
1982
Crayon, felt-tip pen, and ballpoint
pen on paper
11 × 13¾"
Private collection

80. *I Have a Ride at Last*
1982
Felt-tip pen and colored pencil
on paper
9 × 11½"
Private collection

81. *Untitled (Dog)*
1982
Crayon and pencil on paper
24 × 19"
Private collection

82. *Going Home*
1982
Crayon, felt-tip pen, and pencil
on paper
18 × 24"
Private collection

83. *Look Back in Wonder How I Got Over*
1982
Colored pencil and crayon on paper
18 × 24"
Private collection

84. *Black Rooster*
1982
Colored pencil on paper
7½ × 9½"
Private collection

NOT ILLUSTRATED

85. *Handsewn Doll (Angel)*
Date unknown
Navy and red jersey with velvet
21 × 9 × 5"
Private collection

86. *Handsewn Doll*
1970s
Mixed-media
24 × 26 × 24"
High Museum of Art, Atlanta, Norfolk
Southern Collection of Self-Taught Art,
1996.154

87. *Untitled (Chewing Gum Sculpture)*
c. 1975
Chewing gum with plastic flowers,
felt-tip marker, plastic beads, and
hair, on trivet
9½ × 5½ × 6" (base 7 × 7")
Private collection

88. *Untitled (Chewing Gum Sculpture)*
1981
Chewing gum with orange and
black paint
7 × 5½ × 3¾" (base 4½ × 4½")
Private collection

89. *Blue Bird*
1980
Felt-tip pen on canvas board
18 × 24"
Collection of Woodie and
Steve R. Wisebram

90. *Julius Looking into Heaven*
1980
Crayon on paper
18½ × 24½"
Private collection

91. *Untitled (Figure/Animals)*
1980
Crayon on paper
18 × 24"
Collection of Judith M. Anderson

92. *Fish on Spools*
1980
Acrylic paint on wood
7½ × 25 × 1½"
High Museum of Art, Atlanta, pur-
chased with funds from the Georgia
Designer Craftsmen, 1983.20

93. *DeMura Shoe Box*
1970s
Shoe box decorated with five snapshots
13 × 18½"
Private collection

94. *Guest Register*
1971
Crayon on endleaf of guest register
10½ × 7¾"
Private collection

95. *Wallpaper Book*
Textures by Sunworthy, Gilman
Wallcoverings, Inc., Atlanta and
Chattanooga
n.d.
Felt-tip pen and crayon on 35 wallpaper
sheets
9¾ × 12" each sheet
Museum of American Folk Art, gift of
Chuck and Jan Rosenak

(illustrated in black and white on page
26)
96. *Untitled (Fish)*
c. 1950
Pen on ledger paper
8¼ × 13⅝"
Private collection

CHRONOLOGY

1851 Sam Williams, father of Nellie Mae Rowe, is born a slave in Meriweather County, Georgia

1864 Luella Swanson, mother of Nellie Mae Rowe, is born in Fayette County, Georgia

1900 Nellie Mae Williams is born on July 4 in Fayette County, Georgia, the ninth of Sam and Luella Swanson Williams's ten children

1906–16 Attends four years of elementary school and works on the family farm and as a field hand for her neighbors at $1.75 per day

1916 Marries Ben Wheat

1930 The couple move to Vinings, Georgia

1936 Ben Wheat dies

After spending almost a year with her nephew Joe Brown Sr. and his wife, Gracie, Nellie Mae Wheat marries Henry Rowe

1937 Luella Swanson Williams dies

1939 Nellie Mae and Henry Rowe build their house in Vinings, Georgia

1945 Sam Williams dies

1948 Henry Rowe dies

Nellie Mae Rowe returns to an earlier interest in drawing and dollmaking and begins to decorate her house and yard

1976 "Missing Pieces: Georgia Folk Art 1770–1976," Atlanta Historical Society, Atlanta, first exhibition of Nellie Mae Rowe's art

1978 "Viscera," Nexus Gallery, Atlanta, group exhibition of contemporary and folk art

"Nellie Mae Rowe," first one-woman exhibition at the Alexander Gallery, Atlanta, which continues to present various one-woman and group exhibitions featuring Rowe's works throughout the next decade

1979 Travels to New York to view her one-woman exhibition at the Parsons/Dreyfus Gallery, New York

1980–81 Jay Johnson Gallery, New York, group exhibition

1981 Is diagnosed with multiple myeloma in November

1982 The Third Annual Atlanta Life National Competition and Exhibition awards a special tribute to Nellie Mae Rowe

Atlanta Department of Cultural Affairs Grant

Fifth Annual Bronze Jubilee Award, Visual Arts, Atlanta

"Atlanta Women," Nexus Gallery, Atlanta, group exhibition; Rowe attends

Gasperi Gallery, New Orleans, group exhibition

Hammer and Hammer Gallery, Chicago, one-woman exhibition

Middendorf/Lane Downtown, Washington, D.C., group exhibition

Spelman College, Atlanta, one-woman exhibition; Rowe attends

World's Fair, Knoxville, Tennessee, one-woman exhibition

1982–83 "Black Folk Art in America, 1930–1980," Corcoran Gallery of Art, Washington, D.C., traveling exhibition opens January 1982

Continues to draw through June 1982; dies on October 18, 1982; is buried in the Flat Rock A.M.E. Cemetery, Fayetteville, Georgia

1983 Recognition/awards to Linda Connelly Armstrong, producer/director, for film Nellie's Playhouse: Finalist, American Film Festival, New York; Cultural Affairs Winner, Prized Pieces, The National Black Programming Consortium, Inc., Columbus, Ohio; Chathem Valley Foundation Purchase Award, The Atlanta Independent Film and Video Festival, Atlanta; Director's Choice Film, Sinking Creek Film Celebration, Nashville, Tennessee

1983–85 "Nellie Mae Rowe: Visionary Artist, 1900–1982," circulated by the Southern Arts Federation, Atlanta, traveling exhibition

1985 "Atlanta in France," Ministry of Culture of France in conjunction with the Bureau of Cultural Affairs in Atlanta, Chapelle de la Sorbonne, Paris, and Refectoire des Jacobins, Toulouse

1986 "Muffled Voices: Folk Artists in Contemporary America," presented by the Museum of American Folk Art at the PaineWebber Art Gallery, New York

"Nellie Mae Rowe: An American Folk Artist," The Studio Museum in Harlem, New York

"Nellie Mae Rowe: Visionary Artist," Gertrude Herbert Memorial Institute of Art, Augusta, Georgia

"Word and Image in American Folk Art," Bethel College, North Newton, Kansas

1987 "Inner Resources: The Self-Trained Artist in Georgia," Marietta-Cobb Fine Arts Center, Marietta, Georgia

"Two Black Folk Artists: Clementine Hunter and Nellie Mae Rowe," Miami University Art Museum, Oxford, Ohio

CBS News "Sunday Morning" anchored by Charles Kuralt; segment on Clementine Hunter and Nellie Mae Rowe airs February 15

1988 "Gifted Visions: Contemporary Black American Folk Art," Atrium Gallery, University of Connecticut, Storrs

"Not So Naive: Bay Artists and Outsider Art," San Francisco Craft & Folk Art Museum, San Francisco

"Outside the Mainstream: Folk Art in Our Time," High Museum of Art at Georgia-Pacific Center, Atlanta

"Women of Vision: Black American Folk Artists," Aetna Institute Gallery, Hartford, Connecticut

1991 "Georgia Folk Art," joint exhibition at Gainesville College and The Quinlan Art Center, Gainesville, Georgia

"Spirits: Selections from the Collection of Geoffrey Holder and Carmen de Lavallade," Katonah Museum of Art, Katonah, New York

1993 "Nellie Mae Rowe," Alexander Gallery at the Outsider Art Fair, Puck Building, New York

1993–95 "Passionate Visions of the American South: Self-Taught Artists from 1940 to the Present," New Orleans Museum of Art, New Orleans, traveling exhibition

1994 "Community Fabric: African-American Quilts and Folk Art," Philadelphia Museum of Art, Philadelphia

"Every Picture Tells a Story: Word and Image in American Folk Art," Museum of American Folk Art, New York

1994–97 "The Studio Museum in Harlem: 25 Years of African-American Art," The Studio Museum in Harlem, New York, traveling exhibition

1995 "The Leaven in the Bread," Phyllis Kind Gallery, New York

"Pictured in My Mind: Contemporary American Self-Taught Art from the Collection of Dr. Kurt Gitter and Alice Rae Yelen," Birmingham Museum of Art, Birmingham, Alabama, traveling exhibition

1995–96 "Tree of Life: The Inaugural Exhibition of the American Visionary Art Museum," American Visionary Art Museum, Baltimore

1996 "Nellie Mae Rowe," Morris Museum of Art, Augusta, Georgia

"Souls Grown Deep: African-American Vernacular Art of the South," City Hall East, Atlanta

"Women and Voice," Seton Hall University, South Orange, New Jersey

1998 "Friendly Persuasion: Folk Art from the Collection of the Chase Manhattan Bank," The Montclair Art Museum, Montclair, New Jersey

"Womenfolk," Wesleyan College, Macon, Georgia

1998–99 "Self-Taught Artists of the 20th Century: An American Anthology," Museum of American Folk Art, New York, traveling exhibition

1999 "The Art of Nellie Mae Rowe: Ninety-Nine and a Half Won't Do," Museum of American Folk Art, New York, traveling exhibition

PUBLIC COLLECTIONS

Clark Atlanta University Galleries

High Museum of Art, Atlanta

J.B. Speed Art Museum, Louisville, Kentucky

The Library of Congress, Folklife Center, Washington, D.C.

Milwaukee Art Museum

Morris Museum of Art, Augusta, Georgia

Museum of American Folk Art, New York

Museum of International Folk Art, Santa Fe, New Mexico

National Museum of American Art, Washington, D.C.

Schomburg Center for Research in Black Culture, New York

Spelman College, Atlanta

The Studio Museum in Harlem, New York

SELECTED READINGS

Alexander, Judith. *Nellie Mae Rowe: Visionary Artist, 1900–1982.* Atlanta: Southern Arts Federation, 1983.

Arnett, Paul, ed. *Souls Grown Deep: African-American Vernacular Art of the South.* New York: Schomburg Center for Research in Black Culture. In press.

Barrett, Didi. *Muffled Voices: Folk Artists in Contemporary America.* New York: Museum of American Folk Art, 1986.

Cerny, Charlene, and Suzanne Seriff, eds. *Recycled, Re-Seen: Folk Art from the Global Scrap Heap.* New York: Harry N. Abrams in association with the Museum of International Folk Art, 1996.

Cosentino, Donald J., ed. *Sacred Arts of Haitian Vodou.* Los Angeles: UCLA Fowler Museum of Cultural History, 1995.

Gates, Henry Louis Jr. *The Signifying Monkey: A Theory of Afro-American Literary Criticism.* New York: Oxford University Press, 1988.

Gruber, J. Richard, and Xenia Zed. *Nellie Mae Rowe.* Augusta, Ga.: Morris Museum of Art, 1996.

Gundaker, Grey. "'Face Like a Looking Glass': Countenance, Cosmology, and Transformation." In *"More Than Cool Reason": Black Responses to Enslavement, Exile, and Resettlement.* Haifa, Israel: University of Haifa, 18–20 January 1998.

Johnson, Jay, and William C. Ketchum Jr. *American Folk Art of the Twentieth Century.* New York: Rizzoli International Publications, 1983.

Lippard, Lucy R. *Mixed Blessings: New Art in a Multicultural America.* New York: Pantheon Books, 1990.

Livingston, Jane, and John Beardsley. *Black Folk Art in America, 1930–1980.* Jackson, Miss.: University Press of Mississippi and the Center for the Study of Southern Culture for The Corcoran Gallery of Art, 1982.

Longhauser, Elsa, Harald Szeemann, and Lee Kogan. *Self-Taught Artists of the 20th Century: An American Anthology.* San Francisco: Chronicle Books in association with the Museum of American Folk Art, 1998.

Major, Clarence. *Juba to Jive: A Dictionary of African-American Slang.* New York: Penguin Books, 1994.

Maresca, Frank, and Roger Ricco. *American Self-Taught: Paintings and Drawings by Outsider Artists.* New York: Alfred A. Knopf, 1993.

Nellie Mae Rowe: Folk Artist—Vinings, Ga. Produced by Charles Brown. 13 min. Charleston Communication Center, 1975. Videocassette.

Nellie's Playhouse. Produced and directed by Linda Connelly Armstrong. 13 min. Center for Southern Folklore, 1983. Videocassette.

Patterson, Tom. *Àshe: Improvisation & Recycling in African-American Visionary Art.* Winston-Salem, N.C.: Diggs Gallery at Winston-Salem State University, 1993.

Perry, Regenia. *What It Is: Black American Folk Art from the Collection of Regenia Perry.* Richmond, Va.: Anderson Gallery, Virginia Commonwealth University, 1982.

Puckett, Newbell Niles. *Folk Beliefs of the Southern Negro.* New York: Dover Publications, 1969.

Rosenak, Chuck, and Jan Rosenak. *Museum of American Folk Art Encyclopedia of Twentieth-Century American Folk Art and Artists.* New York: Abbeville Press, 1990.

Sellen, Betty-Carol, with Cynthia J. Johanson. *20th-Century American Folk, Self-Taught, and Outsider Art.* New York: Neal-Schuman Publishers, 1993.

Thompson, Robert Farris. "An Introduction to Transatlantic Black Art History: Remarks in Anticipation of a Coming Golden Age of Afro-Americana." In *Discovering Afro-America,* edited by Roger D. Abrahams and John F. Szwed. Leiden, Netherlands: E.J. Brill, 1975.

———. *Flash of the Spirit: African and Afro-American Art and Philosophy.* New York: Random House, 1983.

Trechsel, Gail Andrews, ed. *Pictured in My Mind: Contemporary American Self-Taught Art from the Collection of Dr. Kurt Gitter and Alice Rae Yelen.* Birmingham, Al.: Birmingham Museum of Art, 1995.

Two Black Folk Artists: Clementine Hunter and Nellie Mae Rowe. Oxford, Ohio: Miami University Art Museum, 1987.

Wadsworth, Anna. *Missing Pieces: Georgia Folk Art 1770–1976.* Atlanta: Georgia Council for the Arts and Humanities, 1976.

Wahlman, Maude Southwell. "Religious Symbols in Afro-American Folk Art." *New York Folklore* XII, nos. 1–2 (1986): 1–24.

———. *Signs and Symbols: African Images in African-American Quilts.* New York: Studio Books in association with the Museum of American Folk Art, 1993.

Westmacott, Richard. *African-American Gardens and Yards in the Rural South.* Knoxville: University of Tennessee Press, 1992.

Wilson, Charles Reagan, and William Ferris. *Encyclopedia of Southern Culture.* Chapel Hill, N.C.: University of North Carolina Press, 1989.

Yelen, Alice Rae. *Passionate Visions of the American South: Self-Taught Artists from 1940 to the Present.* New Orleans: New Orleans Museum of Art, 1993.

LENDERS AND PHOTOGRAPHERS

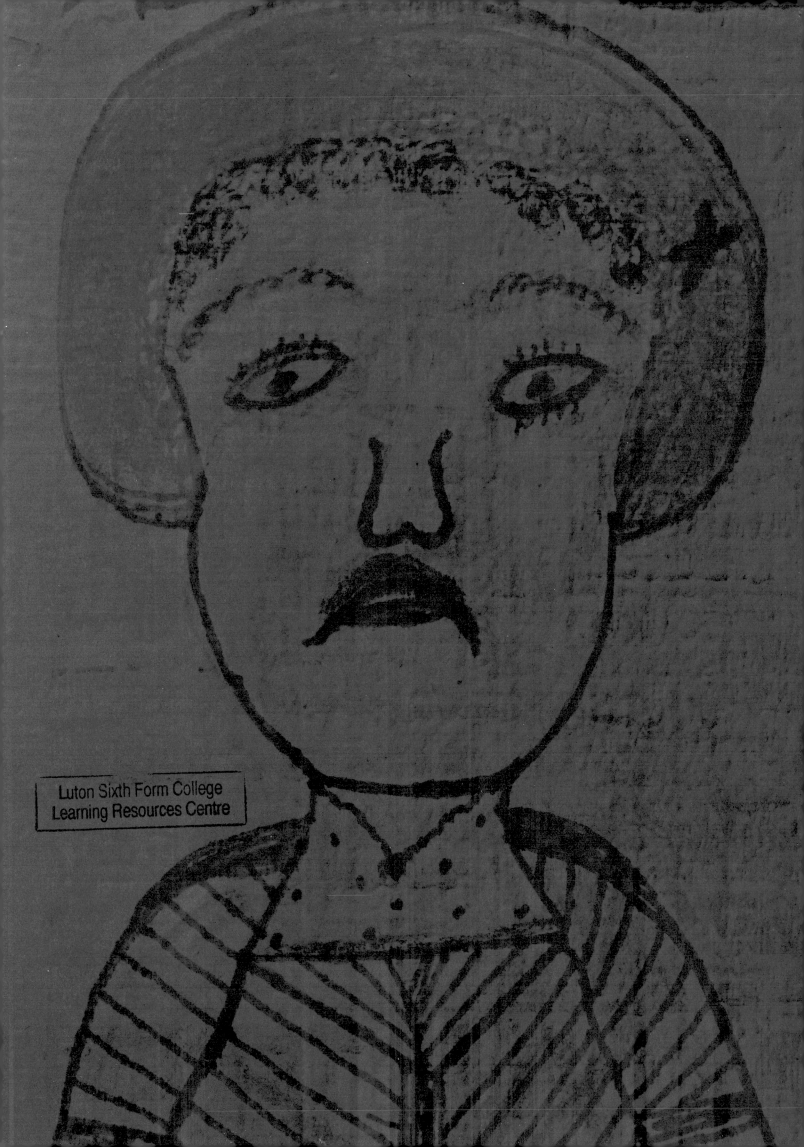